THE

ARTS FOR HEALTH

Series Editor: Paul Crawford, Professor of Health Humanities, University of Nottingham, UK

The *Arts for Health* series offers a ground-breaking set of books that guide the general public, carers and healthcare providers on how different arts can help people to stay healthy or improve their health and wellbeing.

Bringing together new information and resources underpinning the health humanities (that link health and social care disciplines with the arts and humanities), the books demonstrate the ways in which the arts offer people worldwide a kind of shadow health service – a non-clinical way to maintain or improve our health and wellbeing. The books are aimed at general readers along with interested arts practitioners seeking to explore the health benefits of their work, health and social care providers and clinicians wishing to learn about the application of the arts for health, educators in arts, health and social care and organizations, carers and individuals engaged in public health or generating healthier environments. These easy-to-read, engaging short books help readers to understand the evidence about the value of arts for health and offer guidelines, case studies and resources to make use of these non-clinical routes to a better life.

Other titles in the series:

THEATRE

SYDNEY CHEEK-O'DONNELL
University of Utah, United States

United Kingdom – North America – Japan – India
Malaysia – China

Emerald Publishing Limited
Howard House, Wagon Lane, Bingley BD16 1WA, UK

First edition 2021

Reprints and permissions service
Contact: permissions@emeraldinsight.com

British Library Cataloguing in Publication Data
A catalogue record for this book is available from the British Library

ISBN: 978-1-83867-336-9 (Print)
ISBN: 978-1-83867-333-8 (Online)
ISBN: 978-1-83867-335-2 (Epub)

ISOQAR certified
Management System,
awarded to Emerald
for adherence to
Environmental
standard
ISO 14001:2004.

Certificate Number 1985
ISO 14001

INVESTOR IN PEOPLE

CONTENTS

v

ABOUT THE AUTHOR

Sydney Cheek-O'Donnell is an Associate Professor in the Department of Theatre and Associate Dean for Research in the College of Fine Arts at the University of Utah in Salt Lake City, where she teaches new play development, dramaturgy, theatre history, theory, criticism, and dramatic literature.

Currently, she works on the application of theatre techniques in non-traditional places, like healthcare settings and STEM education. She is Principle Investigator, with Dr. Gretchen A. Case, on a randomized controlled trial assessing the effectiveness of a rehearsal framework to improve the interpersonal communication skills of medical learners. This study is funded by the National Endowment for the Arts. She regularly collaborates with multidisciplinary teams at the Utah Center for Excellence in ELSI Research (UCEER) to leverage the arts – particularly theatre and storytelling – in the creation of education and support materials for women and families. Previously, she worked with a multidisciplinary team led by Dr. Nalini Nadkarni to explore using theatre, narrative, and ecological restoration as tools to shift the way people see themselves in relation to science, technology, engineering, and math.

She has earned PhD in Theatre History and Dramatic Criticism from the University of Washington's School of Drama, and received her undergraduate degree from Carleton College in Minnesota.

ACKNOWLEDGEMENTS

The writing of this book would not have been possible without the support of colleagues, friends, and family, particularly in the midst of a global pandemic. I wish to thank Greg Hatch for his amazing skills as a librarian, helping me scour the literature for the evidence base of this book. We spent countless hours in "parallel play," searching for sources and reading through titles, abstracts, and articles. Many thanks also to the scholars and artists who generously took the time to speak with me about their work in the field of theatre for health – some of them responding to email inquiries from a total stranger. Blythe Corbett, Jacqueline Eaton, Peter Felsman, Beth Hagenlocker, and Persephone Sextou: I hope that this volume brings additional attention to your remarkable work.

Additional thanks go to my colleagues in the College of Fine Arts and the Department of Theatre at the University of Utah, who did their very best to help me carve out the time necessary for research and writing: Tim Slover, Harris Smith, John Scheib, Cami Rives, Cami Sheridan, and Aaron Swenson – thank you! My deepest gratitude goes to Gretchen Case and Karly Pippitt, who offered gentle but incisive feedback on various drafts, and cheered me along at every turn. Finally, I wish to thank Nick, for providing honest feedback and running interference with our children.

INTRODUCTION – WHY THEATRE?

[I]t's a ceremony, it's a ritual, it is something which is very important for your mental strength, and you should go out of the theatre stronger and more human than when you went in. (Arianne Mnouchkine, Director)

In the movie *Cast Away*, starring Tom Hanks, FedEx systems analyst Chuck Noland is washed up alone on a desert island following a plane crash. During his four years of isolation, Chuck paints a face on a volleyball, names it Wilson, and treats it as a beloved companion. While in normal circumstances this might be seen as an indication of mental illness, in *Cast Away* we recognize it as a survival technique, a means for Chuck to imaginatively construct social connections where none are possible. We understand, almost instinctively, that social relationships are essential to our well-being and our survival. And when Wilson is finally lost at sea (he's on an island, so this shouldn't be much of a spoiler), we mourn with Chuck as though this now deflated, filthy volleyball were a human character. Human beings are social animals. And while it might be *possible* for an individual to survive in total seclusion, we know that a solitary existence is neither desirable nor healthy. In fact, loneliness is now recognized as being linked to a host of physical, mental, and cognitive challenges as well as to an increased risk of early death. So how do we foster social relationships, particularly at a time when many of us feel both extremely connected (to information) and extremely disconnected (from other people) at the same time?

The answer presented by this volume is *theatre*, a subgenre of live performance that includes narrative, costumes, a playing space, spectators, and a text that is sung or spoken by performers engaged

in planned movement ("blocking") or choreography (Westlake, 2017). In ancient Greece, Apollo was the god of both music and healing. But it was his brother, Dionysus, who had the power to alleviate suffering and bring joy to humans. He was the god of wine and theatre. To thank the god for these particular gifts, Greeks held no fewer than five festivals per year in his honor, all of which involved the performance of poems by choruses of 50 young men. Two festivals celebrated the god through the presentation of plays. So important were theatre and the worship of Dionysus that the Athenians built an amphitheater in their city center, tucked into the hill beside the citadel. Here, all of Athenian society gathered annually for the Great Dionysia, watching plays that reflected their shared values, fears, and hopes. Aristotle, our first known drama critic, said that the purpose of tragedy was *catharsis*. That is, like a medical cleansing of the body, tragedy would cleanse the mind and spirit through the purgation of negative emotions. In effect, theatre was seen as an activity that could heal the individual psyche. I would go further, though, and say that the communal nature of theatre, from its earliest documented existence, points toward the belief that engagement with theatre could also promote the health and well-being of the body politic.

The notion that engagement with theatre might offer individuals opportunities for healing persisted, as seen in the work of the Greek physician Soranus during the second century and then the Roman physician Caelius Aurelianus in the fifth century. For patients suffering from various types of mental illness, Soranus and then Caelius Aurelianus recommended that they see a performance at a particular point in their recovery. The type of performance was selected to balance the quality of the patient's emotional or mental state. Someone suffering from "dejection," for example, was advised to see a comic mime (Drabkin, 1951). Presumably this would help lift their mood. During the eighteenth and nineteenth centuries, a number of asylums and psychiatric hospitals across Europe constructed theatres on their grounds or involved residents in performances. Most famous among these is the asylum of Charenton outside Paris, at which the Marquis de Sade wrote and directed several productions while he was confined there as a patient (Jones, 1996). Although participation in theatre activities

was not always seen as having the potential to cure mental illness during this period, it was often employed to keep patients occupied in pro-social activities that emphasized their strengths and "relaxed" their perceived disfunction (Mora, 1957).

During the middle decades of the twentieth century, dramatherapy emerged as a distinct discipline of the healing arts, one that did not just use dramatic activities to supplement other therapeutic approaches or provide "occupation" to people who might otherwise get into mischief. Rather, in dramatherapy the dramatic process itself facilitates therapeutic change (Jones, 1996). Some of the processes of dramatherapy can help us understand how theatre more broadly functions to support well-being and health. According to Phil Jones, two of the most important elements of dramatherapy are "dramatic projection" and "transformation." In dramatic projection, the client engages with a problem by projecting "aspects of themselves or their experience into theatrical or dramatic materials or into enactment, and thereby externalise inner conflicts" (Jones, 1996). Externalizing the conflict allows the client to gain perspective on it, and, thus, develop a new relationship to the problem. Dramatic projection is also engaged by audiences and actors, albeit without the same clinical implications. Transformation in dramatherapy refers to the processes through which events, people, or objects from everyday life are changed by dramatic enactment and assume new significance for the client. Theatre also relies on the transformative power of the imagination, which can generate new understandings among audience members.

While dramatherapy is intended to help people work through particular problems with the assistance of professional dramatherapist, we do not usually go to the theatre in order to achieve a specific therapeutic outcome. Nonetheless, engaging with theatre can result in secondary benefits that are therapeutic or that support well-being. Participating in theatre offers us opportunities to connect with others based on our strengths and interests. Through it, we can shed the stigmatized identities that limit us and instead become actors, storytellers, designers, singers, and dancers. In addition, we build rapport and relationships, which help reduce isolation and increase pro-social behavior. Engaging with the stories of people whose experiences differ from our own can

help us empathize with other points of view, while the aesthetic distance offered by theatrical metaphor can also provide a safe way for spectators to reflect on, process, and create meaning from their own traumatic experiences.

Further, engagement with theatre offers participants a chance to exercise some control. For people who feel marginalized or disempowered, such agency is a formidable tonic that can mitigate the feelings of hopelessness, loneliness, or anxiety that arise in the face of adverse situations. The opportunity to say "no" to something when one feels compelled to say "yes" to every poke and prod in a hospital, for example, can be a real gift. And not to be taken for granted is the chance to engage in something fun, creative, and even joyful.

The collaborative and embodied nature of theatre is precisely what makes it the ideal artistic vehicle to support individual and community health and well-being. Theatre cannot be done by one person alone. It requires a relationship between, at a bare minimum, an actor and a spectator. In addition, the actor and the spectator inhabit a shared space for the duration of the performance. Thus, theatre resides in the body, just as health and well-being reside in the body. But minimalist performances involving only one performer and one audience member are extremely rare. Typically, a team that includes actors, a playwright, designers, a director, technicians, and a stage manager is responsible for creating the theatrical event; and the audience consists of dozens, if not hundreds, of witnesses who share space with the performers who use their bodies to enact stories.

A VERY BRIEF HISTORY OF THEATRE

Between 2 million and 50,000 years ago, during what has been dubbed the "mimetic era" of human evolution, at the same time that humans began to make tools and use fire, we also started to engage in "subjunctive reality," a world that is imagined, wished for, or possible. The ability to imagine things and to conceive the possible enabled us to both make up stories and pretend, which are, of course, fundamental to what we now recognize as theatre. It was anywhere from 100,000 to 50,000 years ago that theatre emerged

in human culture (McConachie, 2011). The earliest documentary evidence of theatrical activity dates only to about 4,000 years ago in Mesopotamia, a territory that covered parts of modern-day Turkey, Syria, Iran, Iraq, and Kuwait. There is also evidence of theatrical activity from around the same time in Egypt. The most extensive trove of evidence of ancient theatrical activity dates to about 2,500 years ago in Athens. This is why most histories of theatre begin with a discussion of Ancient Greek theatre, particularly the tragedies of the playwright Aeschylus.

The purpose of early performance was most likely to build group cohesion (McConachie, 2013). Because theatre makes special demands on us to understand the emotions and intentions of (fictional) others – the very definition of empathy – it seems likely that early theatrical performance also contributed to social interaction, built community, and allowed participants to develop or practice a variety of skills. There is reason to believe that theatrical performance also gave rise to religious rituals intended to process traumatic events that had no logical explanation (McConachie, 2011). Interestingly, this is the opposite of the commonly held view of theatre's origins in ritual, which held sway among historians throughout the twentieth century.

Various philosophers and artists have tried to explain the purpose of theatre. The Greek philosopher Aristotle wrote a treatise on Athenian drama called *The Poetics* in which he explained that the aim of tragedy is *catharsis*, an emotional cleansing among spectators. Examining the plays from this period as well as the festivals at which they were performed, one sees that this theatre also offered object lessons in Athenian citizenship and celebrated Athenian innovations in society and politics. Thus, the Athenian theatre from the fifth century BCE offered spectators both a form of spiritual or psychological healing as well as instruction on what it meant to be an Athenian.

According to the sage Bharata Muni, to whom the Sanskrit treatise on drama called the *Natyashastra* is attributed (c. 100 BCE to 200 CE), theatre functions as a sensory feast that nourishes both the soul and the mind (Westlake, 2017). For Bharata Muni pleasure is fundamental to theatre's efficacy. In addition, this pleasurable

experience should transport spectators to another dimension in which they can reflect on spiritual and moral questions. Thus, in the Sanskrit tradition, the pleasures of theatre sustain health and well-being through nourishment and have the potential to lead to spiritual and intellectual growth. Similarly, Zeami, the founder of the Nō drama in Japan, proposed that the purpose of theatre is to bring about peace and harmony in the heart of the spectator, which in turn will bring stability to the world. Again, his understanding of theatre's function was both individual and communal and to be brought about through an aesthetic experience.

As we review the explicit and implicit purposes of theatre as documented across a variety of cultures and over many centuries, we see several common threads: it offers instruction or the opportunity for enlightenment, supports well-being, aids community-formation, and provides pleasure or entertainment.

The forms of theatre described by Aristotle, Zeami, and Bharata Muni are generally oriented toward a clear division between performer and spectator. Other approaches to theatre do not draw such stark distinctions, and, in fact, deliberately eschew the separation between performer and spectator that has come to dominate many Western performance traditions. These other approaches to theatre instead work to blur the lines between actors and audience members by including audiences in the making of performances or inviting audience members to participate directly in the performance.

Groups that invite people who are not professional (or even amateur) performers to engage in creating theatre typically have as their primary aim something other than entertaining an audience. The specific purposes of such community-based theatre workshops (often referred to as "applied theatre") vary greatly – from changing attitudes about an issue to offering an opportunity for creative self-expression – but, in general, participatory theatre workshops have similar benefits to theatrical performances: they offer an opportunity for participants to learn or grow, support well-being, encourage the formation of community, and provide enjoyment. Although we will discuss the health benefits of traditional theatre spectatorship, much of the focus of this book will be on participatory theatre activities that take place outside spaces that are

typically set aside for theatrical performance, like community centers, schools, and even hospitals.

CHAPTER OVERVIEW

Chapter 1, "What Helps?," provides a summary of the core evidence for theatre's impact on health and well-being. Although much remains to be done, the research available suggests that theatre engagement can enhance social, emotional, psychological, and community well-being. Chapter 2, "Who Can Benefit?," includes case studies that describe the specific application of theatre for health in a variety of different settings, from hospitals to care homes to schools. In Chapter 3, "How Can I Engage?," we demystify theatre by describing some of the ways individuals and community groups can get involved. For health and social care professionals who are interested in brining theatre into their work, Chapter 4, "What Can Professionals Do to Help?," outlines a number of activities that are appropriate for use in clinical, educational, and community-based settings. Detailed instructions are provided for techniques that can be conducted without the guidance of theatre artists or educators. Chapter 5, "What Are the Challenges and Opportunities?," provides readers with an overview of some of the most common barriers to engaging with theatre and the strategies to overcome them. Finally, Chapter 6, "Resources," provides readers with lists of links to useful organizations, suggested further reading, and information on key references.

1

WHAT HELPS?

Studies of theatre's impact on health and well-being vary widely in how they are conducted (methodology), and include everything from individual case studies to quasi-experimental designs. With a few exceptions, most studies involve only a small number of participants, but this is not unusual in the evaluation of arts interventions, including evaluations of creative arts therapies. Many arts engagements involve small groups that meet over an extended period of time. This can make "scaling up" the size of a study or a theatre activity quite challenging without the investment of significant resources. However, according to the World Health Organization, since the turn of the twenty-first century there has been a noteworthy increase in the quantity of research examining the impact of the arts on health (Fancourt and Finn, 2019). Further, the growing recognition of the role that the arts and culture play in individual and community health, well-being, and resiliency, has also contributed to increased funding to support further study.

That said, if we check across the many studies that currently exist, we can see that much of the evidence suggests that theatre engagement is strongly associated with several positive health outcomes. Although these improvements are interrelated, we can divide them roughly into four broad categories:

- Self-regard
- Social relationships

- Mental health and well-being

- Health literacy

The summary below provides readers with a brief overview of the evidence associated with each of these outcomes.

SELF-REGARD

In his book *Way of Being*, psychologist Carl Rogers argues that a successful therapeutic relationship depends upon the therapist's non-judgmental acceptance and support of their client and the belief that the client has "vast resources for self-understanding, for altering her or his self-concept, attitudes, and self-directed behaviour." He dubbed this concept "unconditional positive regard." Ideally, each of us holds within ourselves enough of this positive self-regard upon which to draw in challenging times. But, as the saying goes, we are our own worst critics. In a number of different studies, theatre activities have been found to improve some aspect of self-regard among participants, which suggests that theatre is an important, non-clinical resource upon which we can draw to build unconditional positive regard for ourselves and through which we might be able to offer it to others.

Multiple studies have shown that theatre-based interventions help improve healthcare workers' confidence in their ability to carry out some aspects of their job. For example, diabetes educators reported that participation a theatre workshop offered them a variety of ways to navigate complex situations, which they found empowering (Collier, 2015). Similarly, nursing faculty observed that students who participated in a theatre-based training were more confident communicators (Loth et al., 2016). And palliative medicine clinicians felt that participation in drama workshops had enhanced their competence at providing end-of-life care (Baile et al., 2012). While these studies rely on self-reported outcomes, participants consistently described *feeling* more competent after participating in a theatre workshop than they did before. And a study evaluating the efficacy of a theatre-based training designed for those working in medical oncology (the study and treatment of cancer) suggests that their feelings of increased competence may

not be misplaced. Researchers found that 115 participants in a four-day theatre workshop demonstrated significant improvements in their communication skills (Back et al., 2007).

Theatre engagements have also been shown to improve self-esteem across a variety of populations. Members of an intergenerational theatre group reported feelings of increased self-esteem and self-confidence after participation, which they attributed to learning new skills and to exposure to different perspectives. In addition, participants found that the experience reduced their sense of isolation and loneliness (Anderson et al., 2017). A large, quantitative study conducted at an in-patient psychiatric unit evaluated the impact of using drama in conjunction with therapy on people with schizophrenia. The researchers found that not only did participants demonstrate an improved ability to empathize with others, but they also experienced enhanced self-esteem and self-confidence (Tian et al., 2014). A 10-week theatre course for people in recovery from mental illness also resulted in improvements to participants' sense of self-worth (Moran and Alon, 2011).

Theatre's impact on self-efficacy has been documented in multiple studies. As described by Albert Bandura (2001), self-efficacy is the belief that we are capable of controlling our behavior or elements of our environment, and it is directly connected to the ability to persevere in the face of challenges. One researcher found that recovering addicts believed their participation in a drama workshop helped them learn to manage negative emotions without using drugs or alcohol. The development of new skills and successful completion of difficult activities helped them challenge negative views of themselves and improved self-efficacy (Hardwick, 2014). Two compelling studies that provide evidence of the link between theatre and improvements in self-efficacy focus on interventions designed to disrupt gender-based violence. In a study involving over 500 university students, people who participated in a theatre-based sexual assault prevention program reported significantly increased confidence in their ability to successfully comfort a survivor of sexual assault compared to peers who had received the same content through a lecture (Rodriguez et al., 2006). In a study of a different theatre-based prevention program, researchers surveyed 400 university students who had participated. Results showed

significant increases in understanding of the issues and perceived ability to intervene effectively in a situation involving gender-based violence (Mitchell and Freitag, 2011).

SOCIAL RELATIONSHIPS

Our social relationships are directly related to physical health, mental health, health behavior, and mortality risk (Umberson and Montez, 2010). The inherently communal quality of theatre makes it an ideal artistic medium to counter social isolation; and recent evidence indicates that it can also improve the *quality* of our social relationships. As noted above, members of an intergenerational theatre group indicated that participation reduced their loneliness and provided meaningful social support (Anderson et al., 2017). Likewise, prison residents engaged in a theatre workshop centered on the work of William Shakespeare reported that they had bonded with other participants and acquired new skills that improved their relationships with others. They also remarked on the importance of respect in the workshop setting. Interestingly, the language one participant used to describe this phenomenon reflects the notion of unconditional positive regard discussed above: "From the onset we were not treated like criminals in need of punishment, but people who are capable of good and great things" (Heard et al., 2013).

Several studies conducted using quantitative, scientific methods and control groups complement the above qualitative evidence. In SENSE Theatre®, youth diagnosed with autism spectrum disorder participate in rehearsals and performances of an original musical alongside typically developing peers who model appropriate social behaviors and provide social support. Findings show increased social communication between participants and typically developing peers outside the theatre rehearsal environment. In addition, youth participants demonstrate "clinically meaningful improvement in both cognitive and behavioral aspects of social competence." So, not only do autistic youth[1] interact with

1. Here I am employing the identity-first language that is currently favored by self-advocates in the autism community. Person-first language (e.g., "person with autism" or "child with ASD") is often preferred by family members of and professionals who work with autistic individuals.

peers more, they do so with enhanced skill and understanding. In addition, participants experience reduced anxiety (Corbett, 2014; Corbett et al., 2017, 2019). A randomized controlled trial evaluating the impact of a novel therapeutic theatre intervention for community-dwelling older adults has also shown that participants experience improved social relations with others (Keisari and Palgi, 2017; Keisari et al., 2020).

While increasing social contact is important, so is improving the quality of social interactions. As noted above, prisoners described improvements in their social skills and researchers observed improvements in social skills and social cognition among autistic youth who participated in theatre programs. During and following engagement in theatre activities, dementia patients have demonstrated improvements in speaking ability and awareness of environment. Conversely, professional caregivers have demonstrated increases in their own positive communication behaviors, decreases in negative communication behaviors, and improved interactions with dementia patients overall (Boersma et al., 2017, 2019).

MENTAL HEALTH & WELL-BEING

Well-being is an important resource for mental health. When we experience a sense of well-being, we feel good and are able to function (Centers for Disease Control and Prevention, 2018). We engage in positive social relationships, experience emotional stability, have a sense of purpose, feel competent and good about ourselves, and we are resilient in the face of challenges (Huppert and So, 2013). Several recent studies indicate that theatre engagement can enhance well-being and improve mental health. The theatre intervention for community-dwelling older adults mentioned above, for example, resulted in an increased sense of well-being among participants. In addition, researchers detected a significant reduction in participants' depressive symptoms, which is consistent with other studies examining the impact of theatre on older adults (Keisari and Palgi, 2017; Keisari et al., 2020; Zeisel et al., 2018). Researchers documented statistically significant increases in the well-being of another group of older adults who participated in six weekly theatre sessions (Chung et al., 2018). Hospitalized children have also shown enhanced well-being

following just a single interaction with bedside performers as measured through changes in their vital signs and perception of pain, observation of behavior, and interviews with parents (Alcântara et al., 2016; Sextou and Hall, 2015).

As noted above, while some participants appear to experience an enhanced sense of well-being, others also experience significant reductions in the symptoms of mental illness. A recent study by Felsman, Seifert, and Himle (2019) showed that a 12-week improvisation class for youth, designed to improve social skills, significantly reduced the incidence of social anxiety disorder (SAD) among participants. In fact, the study demonstrated that participation in the workshop, which was led by theatre teachers rather than therapists, was more effective in treating SAD than cognitive behavioral therapy. More study is required, including control group comparisons, but preliminary findings are very promising.

HEALTH LITERACY

Theatre has been used as a teaching tool since at least as far back as the ancient Greeks, so it is not surprising that health educators have employed theatre in their efforts to communicate important information to individuals and communities on a wide variety of topics. Unlike what Paolo Freire termed "the banking model of education," where knowledge is conceived of as something that a teacher deposits *into* students, theatre requires learners to contribute their own experiences, opinions, and understandings to the creation of new knowledge. Thus, theatre offers an educational framework through which health educators and community members can engage in a mutually beneficial exchange that results in an understanding of health in a specific cultural context.

Theatre for health projects whose primary intention is "educational" have focused on three main things: offering accurate information or making scientific research accessible, encouraging self-reflection among participants or audience members, and shifting attitudes or values. This is true regardless of whether the "students" involved are members of the general public or are health and social care professionals. Increased knowledge and related attitude or behavioral

changes have been documented in projects addressing cancer (Cueva, 2010; Cueva et al., 2005, 2012; Friedman et al., 2019; Rustveld et al., 2013), household hygiene (Pleasant, 2017; Pleasant et al., 2015), stigmatized communities (Hui et al., 2019; Logie et al., 2019; Tarasoff et al., 2014), sexual health (Kafewo, 2008; Mitchell and Freitag, 2011; Wells, 2013), and person-centered care (Boersma et al., 2019; Kontos et al., 2012, 2010). Like many studies on theatre for health, these are limited by the fact that most researchers have been unable to follow participants over time. Therefore, we do not yet know how persistent the impacts of these interventions are.

SUMMARY

Many questions about the relationship between theatre and health still remain unanswered; a great deal more study is needed. However, the evidence presented above suggests that theatre provides benefits in four general domains: improvements in participants' self-regard, social relationships, mental health and well-being, and health literacy. Possible mechanisms that underpin the effectiveness of particular theatre for health interventions include:

- engagement in meaningful activities;
- positive, goal-directed social interactions;
- a shared sense of purpose;
- opportunities for self-reflection;
- experiencing positive emotions;
- mastery experiences; and
- supportive, non-judgmental social interactions with others.

Among those who have benefited from the supportive power of theatre are older adults, autistic children and children in hospitals, youth from economically disadvantaged communities, residents of prisons, formal and informal caregivers, and health and social care professionals. The many different communities around the world that have responded positively to a variety of theatre engagements

is encouraging. More encouraging still are the increasing number of collaborations between theatre artists and researchers with an interest in better understanding the what, how, and why of theatre's effect on human health and well-being.

2

WHO CAN BENEFIT?

As discussed in the previous chapter, there is a growing body of evidence to suggest that engagement with theatre can have a positive impact on people living with a variety of physical and mental health conditions. In addition, theatre has been shown to be an effective educational tool both for the general public and for healthcare professionals. This chapter offers several descriptions of theatre for health in action. These examples are by no means exhaustive, but they do illustrate how theatre has been employed successfully in a number of different communities.

CHILDREN AND YOUNG PEOPLE

Bedside Theatre

It is something of a cliché to say that every performance of a play is unique. Every performance happens in real time and the audience changes, which leads to inevitable differences. In bedside theatre for children in hospitals, however, each performance *must* be individualized to address the specific needs of the audience-of-one, the hospitalized child, at a particular moment in time. In addition, bedside performances *must* adjust to the interruptions that may occur in a hospital. It may be something as small as a monitor beeping unexpectedly or as large as a medical emergency, but these intrusions of reality

upon the fiction being co-created by the performers and the child must be addressed and incorporated into the story.

Persephone Sextou has developed several bedside theatre pieces for children who are hospitalized for extended periods of time due to serious illness. These children typically experience a great deal of clinical stress, which negatively impacts not only their psychological well-being, but also the well-being of their caregivers. At the same time, living confined to a hospital can be boring. Having been removed from their usual environment, hospitalized children are isolated from their networks of friends and sometimes they are also separated from family members. The bedside theatre created by Sextou is designed to offer these children an enjoyable, relaxing, imaginative experience in a setting where there is limited opportunity for joy, relaxation, or cognitive stimulation. What makes these performances different than, say, a traditional play, is that the story is enacted collaboratively with the child to whom it is presented. In fact, a major goal of the performers is to engage the child directly in creating the fictional world of the play. The performers do follow a script, but it includes engaging the child in conversation and inviting them to make suggestions that shape the contours of the imagined world. In effect, the child becomes a character in their own short drama.

One of the pieces created by Sextou, "A Boy and a Turtle" (based on a children's book by Lori Lite), engages participants in mindfulness-based stress reduction through collaborative theatre-making. Through the story of Timmy, a boy who befriends a Rainbow, the child and actor venture imaginatively to a park, where they sit by a pond to relax in the warm sun with Rainbow's colors swirling around them. They are joined by the curious Mr Turtle, who wants to know what they are up to. Together, the child, Timmy, and Mr Turtle practice deep breathing and visualize the colors of the rainbow moving from their feet to the tops of their heads (Sextou 2016). Although it is possible to perform this little play in a representational manner, with a clear division between the actors and the audience, the genius of Sextou's bedside theatre is how it achieves the collaborative relationship between the actor playing Timmy and the hospitalized child.

In one sense, the performance begins hours or even a couple of days before the play commences, when a hospital staff member asks the child if they would like to have a theatrical performance at their bedside. Assuming the child accepts the offer, the child and their family members experience the excitement of anticipating what it will be like. The proverbial curtain goes up on a performance of "A Boy and a Turtle" when Timmy – wearing a bright red baseball cap, Hawai'ian shirt, and torn, baggy jeans – asks permission to enter the child's space, which establishes the child's control over the encounter. A hospital room is a space that is regularly traversed by medical staff without the child's permission. Timmy's genuine request transforms the child's identity from passive to active. Even if the child tells Timmy to leave, the performance can be counted as successful because it has allowed the child to exercise autonomy, however briefly.

When Timmy is settled in the room, he begins to tell the child a story about meeting a new friend at the park, and engages the child in a brief, improvised conversation. Once rapport between the actor and the child has been established, the child will agree to meet Timmy's new friend, Rainbow. As the play continues, the actors offer the child various non-threatening, flexible invitations to participate in imagining the setting for their story, which introduces a new way of being in the hospital environment that is characterized by collaboration and creativity. The selection of location is an opportunity for the child to "escape" from the confines of the hospital and to "create a different external reality" that is not associated with illness or pain (Sextou, 2016). The addition of Mr Turtle (represented by a stuffed animal), provides a character to whom Timmy and the child can teach a deep breathing technique to promote relaxation. This intervention is characterized by the projection and transformation Jones (1996) says characterize the processes of dramatherapy. The child projects aspects of their experience in the hospital onto the actors and the puppet. In addition, the actors and the child engage in the transformation of the hospital space and experience through imagination and dramatic enactment.

The children who received this bedside performance responded positively to it. They were attentive throughout (unless they fell asleep) and several children remarked later that they forgot where they were while they were engaged in the play. A number of parents observed positive effects in their children in the days following the performance, including being better able to tolerate medical procedures. Children also remembered the breathing technique they had learned and taught it to others, demonstrating an increased ability to manage their own symptoms (Sextou, 2016; Sextou and Hall, 2015; Sextou and Monk, 2013).

Bedside theatre is a highly individualized and, therefore, adaptable approach to performance. In addition to providing entertainment appropriate for younger children with serious medical conditions, the performance also helped to reassert the child's identity beyond being a "patient" or "sick" by engaging them actively in a collaborative creative endeavor and by teaching them a set of important skills for the self-management of both physical and emotional discomfort.

Improvisation for Social Anxiety

In 2012 a group of actors who had once lived in Detroit, Michigan, responded to that city's economic crisis by establishing the Improv Project. What they didn't anticipate was that the curriculum they eventually developed and deployed in Detroit's underfunded public schools would significantly reduce the prevalence of social anxiety disorder (SAD) among its participants. Having been engaged in improvisational theatre for many years, the actors collaborated with community arts organizations, teachers, and public school officials to develop and offer a 10-week improvisational theatre curriculum to be taught in schools (Jackson, 2017).

More than half of the students in Detroit live in poverty and are at high risk for dropping out before they graduate from high school. As Marc Evan Jackson, one of the Improv Project's founders put it during a public talk in 2017, "[These students] have been told, 'things are probably not going to happen for you.'" In other words, many people expect that students enrolled in publicly funded Detroit schools are destined to a life of failure and poverty. When

that is the message a student receives regularly, it is no wonder that attendance rates are low and academic performance suffers.

Given the fact that participants would not necessarily have an interest in theatre as an artform, the Improv Project team developed two threads to their course: the first related to the theatre skills being learned, while the second, in parallel, outlined the applied life skills being learned via improvisation. Take, for example, the theme of week 3 in the Improv Project syllabus: "Environment." Improvisation is generally done with no sets, costumes, or props. Actors create the environment in the imagination of the audience through what they do and say. This element of improvisation helps develop observational skills, which are useful for problem-solving and for relationships, not just for making theatre.

Course facilitators invite but do not force participation in class-room activities. Instead, they find ways to encourage the engage-ment of reluctant students. For example, if a student does not want to participate in a particular game, the facilitator might ask them for their opinions about what their peers are doing. Over time, students who were hesitant at first gradually became more engaged with the activities, and in some cases they even became eager participants. In one school, where the typical attend-ance rate was about 60% on a Friday afternoon, the attend-ance rate among students enrolled in the Improv Project course was 98% at that same time (Jackson, 2017). Over the course of 10 weeks, students learn a variety of improvisational skills that can be applied to everyday life. At the end of each course, students are able to share what they have learned with their family and friends in a final public performance.

Theatre for Autistic Youth

Because of the difficulties many autistic people experience with social interaction, communication, and flexibility, it can be par-ticularly challenging for parents to find enjoyable and meaning-ful group activities that embrace and support the needs of autistic children. The fundamentally social nature of theatre as well as its demand for a certain amount of flexibility among participants seem to buffer against the idea that theatre might be appropriate,

let alone welcoming, to autistic youth. However, it was precisely because of theatre's focus on social relationships, communication, and flexibility that Blythe A. Corbett (2014) created SENSE Theatre®. As introduced in Chapter 1, autistic youth enroll in a theatre program side-by-side with non-autistic peers. Over the course of 10 weeks, participants develop their acting skills and rehearse a musical, which is presented to the public. While SENSE Theatre® has a number of very specialized features, it builds on practices that are familiar to most theatre practitioners. Ultimately, acting is the vehicle for autistic youth to practice and explore social interactions in a supportive setting.

The SENSE Theatre® program takes place over 10 sessions, usually a single meeting per week for 10 weeks. Each day, children arrive and are immediately and warmly welcomed by staff members, counselors, and peer actors, who have received training to serve as mentors. The first day's rehearsal begins with introductions, during which staff and peers model appropriate social behaviors expected of participants in a natural environment. Next, the program director outlines the basic rules of participation, which emphasize safety and courtesy, discusses the objectives of the program, and reviews the schedule of the day's activities. When an activity is completed, a participant is invited to cross it off the agenda, which is posted where everyone can see it.

Once the foundations have been laid, a theatre director holds auditions for the show that the group will rehearse and present at the end of 10 weeks. In SENSE Theatre®, auditions are framed as an opportunity to share hidden talents and get to know participants, rather than as a make-or-break moment in which performers must prove themselves to be "right" for a particular part. The director invites each child to stand on stage, give their name and a state a personal interest. Because failure to do so can unintentionally reinforce a refusal to participate, peers and staff offer plenty of praise for each participant's efforts in the process. Participants are then cast in roles that can be adapted to match their individual strengths.

Each session includes a mix of theatre games and exercises with preparation for the final performance. Participants learn songs, rehearse scenes, memorize lines, and develop characters alongside

their peer mentors, who will also appear in the play. During periodic breaks, participants and mentors are able to socialize informally. This offers a natural environment in which participants are encouraged to engage with other youth, which helps them practice newly acquired skills in a novel setting. As the end of each meeting nears, participants receive their homework assignments, which are intended to reinforce and generalize what they are learning in rehearsals. These may include observational tasks, working on characterization, practicing target behaviors, or video modeling. Before departure, the director offers specific praise to participants for their work and provides a preview of the upcoming rehearsal, something that autistic people tend to find helpful. Staff members follow up with families after each session via email, providing feedback on the day and information on any assignments. Each 10-session SENSE Theatre® program ends with a fully realized public performance that showcases the hard work and unique talents of each participant.

ADULTS

Theatre for Medical Education

At the University of Utah School of Medicine, Gretchen Case and I offer a theatre-based workshop in breaking bad news called Coached Rehearsal Techniques for Interpersonal Communication Skills (CRiTICS). In addition to introducing the generally agreed upon best practices for this particular type of difficult communication scenario, CRiTICS provides students with the opportunity to rehearse delivering bad news under the supervision of an acting teacher. We employ acting teachers to lead these sessions because they are typically able to analyze complex behavior quickly and provide specific, "playable" feedback to learners, regardless of whether they are actors or medical students. Every hour in medical education has to be carefully planned due to accreditation standards. To mitigate for this limitation on time to develop skills in difficult communication, the instructor efficiently and effectively provides feedback on what amounts to a performance.

CRiTICS is not meant to replace the supervision of trainees by experienced medical doctors during their time in medical school; rather it is meant to teach students a valuable framework they will be able to use throughout their education and careers, namely, theatrical rehearsal. Rehearsal is fundamentally a mode of experiential learning: you plan something (a scenario or scene), try it out, analyze what you just did, and decide on revisions that will improve the scene. Then you try it again with the revisions in place, and repeat the cycle until you present the final product to your audience on opening night. In the healthcare setting, "opening night" is the moment that a provider interacts with a patient.

We hold CRiTICS workshops in clinical simulation suites at the medical school in order to provide a high-fidelity rehearsal experience for students. In addition, we hire actors to play the role of the patient or family member to whom the student must disclose bad news. Employing actors in these roles, rather than asking medical students or faculty to play patients, provides an additional level of realism to the experience. Actors are able to stay in character and improvise realistic responses to what the students do and say.

A typical CRiTICS workshop is led by an acting teacher who is assisted by the actor playing the role of the patient or family member. In order to ensure that each student has an opportunity to rehearse the scenario, we limit the number of students in each session according to the amount of time available. For a 50-minute session, for example, only two students will participate. Sessions begin with brief personal introductions, during which the teacher explains the concept of performance in everyday life: we all play roles that depend upon the context in which we find ourselves. These roles at least partially dictate our behaviors. Thus, in some sense, we are all actors. In addition, the teacher provides a brief overview of what they will be doing during their session (i.e., rehearsing a bad news disclosure in a supportive environment) as well as the overall goals of the session.

Before rehearsing the scenario, the teacher engages learners in a simple acting warm-up designed to encourage being "in the moment" through physical and emotional self-awareness and attention to one's surroundings. Typically, this is accomplished through a combination of mindfulness techniques and theatre games.

For example, one teacher guided students through a breathing exercise and followed up with a mirroring game. During the breathing exercise, she asked students to turn their attention inward to the quality of their breath and any tension in their bodies. In the mirroring game, each student took a turn as the leader, moving slowly while their "mirror" (the other student) attempted to imitate their movements as precisely and smoothly as possible. The goal of this game is to make it difficult for an observer to differentiate between the leader and follower by synchronizing movement as much as possible.

After the warm-up, each student has at least two opportunities to rehearse the scenario opposite the actor playing their patient. Between each try, the teacher and students reflect on what happened and how it felt, and the teacher suggests one or two specific adjustments the student might attempt next time. The student then has the opportunity to test and reflect on the effect of any adjustments. Once all students have had an opportunity to rehearse, the acting teacher asks them to reflect on their experiences and together they summarize key "takeaways" from the session.

Currently, data analysis of a randomized controlled trial assessing the effectiveness of CRiTICS is under way at the University of Utah. The study is funded by the National Endowment for the Arts, and results will be published at arts.gov when they become available.

Theatre for Recovery

In 1998, Phil Fox, an actor and recovering addict[1], founded the Outside Edge Theatre Company whose vision is to alleviate "the suffering of people affected by addiction" and to bring "about change in their lives through performance" (Fox, 2014). Fox believed that his life had been saved by theatre because it provided him with a creative outlet through which he could safely explore his emotions and construct meaning following an upbringing characterized by abuse, substance misuse, and abandonment. The creative choices offered through the craft of acting seemed to offer a way

1. This is the term he used to describe himself in writings about his work.

to understand, viscerally, that he and others struggling with addiction could make different, more positive choices in their real lives. Theatre, it seemed to Fox, offered the option of being an actor in one's own life, a powerful message for someone whose identity has been shaped by the notion that they are unable to make choices because their addiction is simply too powerful to resist or overcome. Addicts are, as James Reynolds puts it, under the "influence." Outside Edge attempts to flip the script by developing participants' self-efficacy – or the ability to *influence* one's surroundings and choices – through the craft of acting.

At Outside Edge, in west London, Fox developed the Theatre Skills Progression Programme (TSPP), staged full theatrical productions for a variety of audiences, and offered training for professionals working with people affected by addiction. The TSPP was a weekly workshop offered to people in all stages of recovery and with all levels of acting experience. TSPP has since evolved into two different sections: Drop-in Drama, for beginners and people at earlier stages of recovery, and Edge Two, which offers more advanced training to people who are stable in their recovery and who have demonstrated a commitment to Drop-in Drama. People who advanced through the training course and maintained their recovery might eventually become paid performers in the company's professional productions, which toured recovery centers, prisons, and theatres. By 2011, Outside Edge had reportedly worked with over 10,000 people affected by substance misuse (Reynolds, 2017).

Outside Edge's show *Border Crossing* was commissioned as an educational piece for staff working with people affected by substance misuse. Centered around a 15-year-old girl named Karen, *Border Crossing* traces the causes and effects of intergenerational substance misuse. This short play, devised collaboratively by Fox and three actors, is immediately followed by a "forum." Forum Theatre was originally conceived by Brazilian director and playwright Augusto Boal as a way to resist political oppression in Brazil in the 1960s and 1970s. Boal later adapted these methods to address the internalized oppression that he observed in post-industrial, democratic societies. In Forum Theatre, a company of actors presents a short play illustrating an oppressive situation in which the problem is *not* solved during the scripted plot. After the actors run through the play's action once,

they begin again. This time, a facilitator called the Joker invites audience members to interrupt the action and suggest alternative courses of action for the protagonist. The other actors adjust to the changes, improvising what they think are realistic responses to the proposed solutions. Actors playing "oppressors" are meant to continue to pursue their goals vigorously, and often create new, unforeseen barriers to the protagonist's attempts at liberation. This performance and the discussion that arises between the Joker and the audience members constitute "the forum." According to Fox, the audience for *Border Crossing* eagerly entered the forum, suggesting alternative courses of action and debating who should be responsible for resisting the oppression in the play.

Phil Fox died in 2014, but his work continues through Outside Edge Theatre Company, which has now expanded its reach by offering creative writing sessions, groups specifically for women affected by addiction, and an award for plays that address the topic.

OLDER ADULTS

Reminiscence Theatre

Reminiscence Theatre, developed by Pam Schweitzer in the 1980s, is one approach to theatre-making that draws on the memories of older adults to supply the raw material from which a play is generated, usually by a company of professional theatre artists. In Schweitzer's approach, an acting company visits, for example, the residents of a care home and interviews them about their lives in groups and individually. The company transcribes the interviews, sorts through the material generated, conducts improvisations, and develops scenes based on this material. Then members of the company return to the community to show contributors a "draft" of the scenes. Participants provide feedback and make corrections as necessary. Sometimes additional detail is elicited from participants during rehearsals and is later incorporated into the final performance. Once the script is complete and the company has rehearsed, they perform the piece not just for the participants in the workshop, but for the other residents in the community, as well as for family and staff.

Residents who participate in this type of theatre-making activity benefit from the increased positive social interaction that occurs when they share their stories with one another. They experience the pride of being content experts whose contribution shapes a public, professional theatrical performance. And other residents who may not have participated in the process of making the play also benefit, as the performances typically serve as inspiration for their own reminiscences during the discussions that take place after the play. Staff also see residents in a new and more complex light, which can improve care (Schweitzer, 2007).

Reminiscence Theatre has been adapted for individuals living with dementia and their caregivers, engaging with embodied expression through both role-play and reminiscence objects (e.g., a childhood toy) rather than personal narrative. It also focuses on engaging participants in creative processes rather than on trying to generate a final product that will be performed for spectators. A workshop for groups including people with dementia and their informal caregivers explored a different theme each week, such as childhood or first jobs, using a mix of improvisation, interaction with props ("reminiscence objects"), prompted visualizations, and role-play.

Theatre offers us a way to conceive of engaging with people with dementia as full of potential, rather than suffused with loss (Gray 2017). The embodied nature of theatre invites us to focus on the many different ways in which we express ourselves, not just through spoken or written language. Refocusing attention on the "social and cultural habits, movements, and other physical cues" of people with dementia enables us to gather a great deal of information about them as individuals, and, thus, provide more meaningful care that goes beyond addressing physical need alone.

According to Schweitzer, this embodied reenactment of events helped some participants access memories and abilities that family members believed were long-forgotten. One frail and extremely elderly woman with dementia

terrified her husband when she started skipping with a rope and would not stop until she had done 24 skips, presumably some magic target recalled from a long ago time, for which she received tumultuous applause from the whole group.

In another instance, Schweitzer ran a three-legged race with a dementia patient who usually had great difficulty walking. Evidently engaging in a creative activity with others boosts confidence and forges social connection. The positive emotions generated by creative, social experiences linger even if participants don't remember precisely how they managed to impress friends and family (Schweitzer, 2007).

CONCLUSION

The case studies presented above offer a range of examples of theatre for health in action, but they are by no means a complete catalog of the work in this domain. Although not without its challenges, theatre can be employed in a wide variety of settings (e.g., hospitals, community centers, and universities) with people at all stages of life and in varying states of health. In each case, theatre offers participants ways to learn new things, express themselves through creativity, and work with others toward shared goals.

3

HOW CAN I ENGAGE WITH THEATRE?

There are a variety of ways in which to engage with theatre depending upon your interests, available time, location, and whether you want to participate or spectate. Below is a menu of options, including instructions for specific activities you can do on your own or with others, information on how to get involved in theatre, and suggestions for making the most of your theatre-going experiences. This is not a complete list of all the possible ways to engage with theatre, but it should give you some ideas about where to start.

THINGS TO DO

Read a Script

Although plays are meant to be acted out in front of an audience, there is nothing wrong with reading a play script. Reading plays makes an infinite number of stories available at low or no cost in the comfort of your own home – regardless of whether you live in a city or in the countryside. If you'd like to give it a go, libraries are a wonderful place to start your search for something to read. Bookstores often have plays available for purchase, as do gift shops connected to theatres. There are also specialty publishers of plays from whom you can order directly, including Samuel French, Dramatists Play Service, and Nick Hern Books. If you are

interested in brand new plays, the New Play Exchange makes the world's largest digital library of plays by living writers accessible for a small subscription fee (newplayexchange.org).

If you don't already have an idea about what to read, drama anthologies are carefully curated by literature or theatre scholars and provide introductory essays that put the plays into context. Some anthologies provide an overview of theatre history and contain dozens of plays, while others are more narrowly focused on a particular playwright, genre, or period. Another approach is to look at what is playing in theatres right now. Producers put considerable thought into selecting plays that they believe their audiences will enjoy or find meaningful. To find out what's playing in New York or London, two of the great theatre cities in the world, take a look at the theatre reviews on TimeOut.com. You can also visit the websites of repertory theatres to see what they are producing – the National Theatre, Old Vic, and Birmingham Repertory Theatre in the UK, and the Guthrie Theatre, Goodman Theatre, and the Old Globe Theatre in the USA, for example. Lastly, you could search the internet for lists of "must-read" plays. There are lots of lists curated by various organizations and individuals.

Unlike novels or poems, play scripts are not finished products. Rather, they are blueprints for live performances. Thus, it takes some time to learn how to interpret the words on the pages of a script. When you read a play, you will generally see two types of text: dialogue (what the characters say to each other) and stage directions (descriptions of what you would see happening on stage when the script is performed). Most of us focus on the words the characters speak for obvious reasons: they give us clues about their feelings, thoughts, and motivations. But playwrights use stage directions to provide audiences with important information that is not delivered through on-stage speech. If you skip the stage directions, you might miss an important plot point like, "He discovers the buried treasure."

Because you must switch between reading dialogue and stage directions, it is wise to take your time. If you find that there are too many characters to keep track of easily, try making a little diagram or list of relationships to which you can refer while you read. Some scripts come with a drawing of the stage in the back of the book. If that is not the case for your play and the playwright describes the

scenery in detail, you could sketch a rough floorplan of the space based on the stage directions. Each of these strategies will help develop your capacity to imagine the characters and the action as you read.

An excellent book with guidance on how to read plays is *Backwards and Forwards: A Technical Manual for Reading Plays* by David Ball. It's a short, entertaining read.

Do a "Reading"

If you would like to take your exploration of theatre a little further, reading a play aloud (typically referred to simply as a "reading") with friends or family is a logical next step. As discussed above, a play's script reflects only a small percentage of a complete theatrical text, which includes spoken or sung dialogue, movement and gesture, and design elements like costume, set, lighting, and sound, among other things. Coordinating all of these elements is an enormous undertaking, but reading a play aloud with others requires only enough copies of the play to be shared among the people reading lines, making it both economical and flexible. No memorization, movement, costumes, or sets are required. If you plan to read a play to an audience, a *rehearsed* reading may be in order. As the name suggests, a rehearsed reading involves prior preparation, and is discussed in the next chapter.

Playwriting

In his famous 1968 book *The Empty Space*, director Peter Brook writes,

> *I can take any empty space and call it a bare stage. A man walks across this empty space whilst someone else is watching him, and this is all that is needed for an act of theatre to be engaged.*

The *script* in this case is a single stage direction: "An actor walks across the stage." Even this simple script requires at least two people to become "theatre": the actor and the audience (Brook, 1977). But who came up with the idea for an actor to walk across

this empty space? The answer, of course, is the playwright, who conceives an idea and shapes it into a script for enactment in time and space in front of an audience of one or more. A script is not theatre. Rather it is a set of instructions for a live theatrical event. It's similar to an architectural blueprint. Just as an architect requires engineers and technicians to transform a blueprint into an actual building, so, too, does a playwright require other artists and technicians to transform a script into "a play."

As Brook indicates above, scripts need not be elaborate or long. In fact, a play can last just a few seconds (e.g., Samuel Beckett's *Breath*). In other words, if you are interested in writing a play, you don't need to start out with a three-hour extravaganza. In order to overcome feelings of anxiety about putting proverbial pen to paper, try to think of what you are writing as a sketch (if you are a visual person) or a rehearsal (if you are a performer) or an experiment (if you are a scientific person).

The world's first dramatic theorist, the Greek philosopher Aristotle, wrote in *The Poetics* that drama has six component parts: plot, character, diction, thought, music, and spectacle. His understanding of drama was based on the theatre he witnessed in Athens during the third century BCE. But the beating heart of drama consists of just characters and conflict. The characters need not be human, and the conflict need not be earth shattering. But there must be characters of some kind, these characters will have desires, and something or someone will impeded the fulfillment of those goals. Consider the American sitcom *Seinfeld*, for example, a show that is famously described as one in which nothing happens. This is not true, of course. Lots of things happen. But the conflict usually centers on a mundane activity, like parking a car. It would therefore be more accurate to say that nothing of great importance happens. Yet there is plenty of conflict!

The following deceptively simple exercises help beginning writers focus on conflict as a dramatic building block.

What You Need

Something to write with (paper and pen or a computer) | A quiet place to work

Methods

Opposing Desires: Write a short (3–5 pages, double-spaced) scene in which two characters (A and B) try to achieve diametrically opposed goals. The characters find themselves together in an enclosed space of some kind. Character A wants to leave more than anything. Character B wants A to stay more than anything. By the end of the scene, one of the characters must "win" (i.e., achieve their goal), but neither character may use violence or the threat of violence to do so.

Here are some questions you may want to consider as you write:

- Who are A and B?

- What is their relationship to each other?

- How do they feel about each other?

- Where are they? How did they get here?

- Why does A want to leave so much?

- Why does B want A to stay so much?

- What will each character do in order to get what they want? What *won't* they do?

- Who will win?

Once you have completed a draft of your scene, try reading it aloud to yourself so you can hear what it sounds like. Better yet, invite a couple of friends to read it aloud for you. This will give you a better sense of how it sounds and how other people might interpret what you've written. Revise based on your impressions or reader/audience response.

It's Over: Write a short (3–5 pages, double-spaced) scene about the end of a committed relationship. You may define "committed" and "relationship" as you see fit. One character should want to end the relationship. The other should want the relationship to continue. By the end of the scene, one character should have achieved their desired outcome. Avoid resorting to the use of violence.

Here are some questions to consider as you write:

- Who are the characters? (Social class, educational background, national origin, etc.)
- What is the nature of this relationship? What is its duration?
- Why does one character want to end the relationship? Why does the other one want it to continue?
- What is at stake for these characters? For their world?
- Where does the scene take place? Is it a private space or a public space?
- When does the scene take place? (Time of day, year, season, etc.)

Interested in learning more about playwriting? There are dozens of good books on the subject, as well as YouTube videos and podcasts. See Chapter 6 for more information.

Improv

Improvisational theatre ("improv") is a genre that dates back hundreds, if not thousands, of years. In its purest sense, improv is defined as theatre that is created spontaneously by performers without the benefit of a pre-determined script. Characters, story, dialogue, props, and costumes are all created by the actors in collaboration and in real time during the performance (i.e., without rehearsal). Often the actors begin with a set of given circumstances (e.g., the location and relationship between characters). But the cardinal "rule" in improv can be boiled down to one phrase: "yes, and." This phrase, spoken from the point of view of the actor, indicates that the actor in an improvisation will accept the creative offering made by their acting partner(s), and then build on that offering with their own contribution.

The first episode of the British television sit-com *Life's Too Short*, created by Stephen Merchant and Ricky Gervais with Warwick Davis (2013), offers an excellent example of what happens to an improvisation when an actor does *not* observe this basic rule. In the scene, Liam Neeson visits Merchant and Gervais at

their office and demands that they stop their meeting to do some improvisational comedy with him. Neeson turns to Davis, who is sitting next to him, and orders him to give them a scenario. Davis suggests that Neeson play a hypochondriac and Gervais a doctor. Neeson accepts the suggestion and begins the scene but almost immediately rejects what Gervais "offers":

Neeson: Knock-knock.

Gervais: Come in!

Neeson: Hello.

Gervais: (*annoyed*) Oh no! Not you again!

Neeson: I've never been here before.

Gervais: (*hesitates*) Sorry ... (breaking character) I thought, 'cause you're a hypochondriac, you would have been to the doctor's before.

Neeson: Don't presume. That's a backstory we didn't agree on beforehand.

Gervais: (*beat*) But that's improv though, isn't it? You sort of go with the flow.

Neeson: (*matter-of-factly*) I don't take notes.

Gervais: Ok.

Neeson: Can we go again?

Gervais: (quickly, overlapping) Yeah.

Neeson: Because you ruined that.

Gervais: Sorry.

They try again and Neeson continues to derail the progress of the scene by summarily rejecting each of Gervais's suggestions. In addition, he makes wildly inappropriate choices for "improvisational comedy," a popular subgenre of improvisational theatre that is often called "sketch comedy." Neeson's bizarre choices and his refusal to enter into the spirit of improvisation by saying "yes, and" to Gervais produce hilarious results.

Although the most influential improv troupes of the past 75 years are ones that have launched the careers of comic actors, directors, and writers, not all improv achieves, or intends to result in, comedic performances. Improvisational techniques are used frequently in acting classes, theatre workshops for community groups, rehearsals for scripted plays, and in new play development. There is an appropriate improvisational exercise or game for almost any purpose.

If you have never done improvisational theatre but would like to learn more, the best way to do that is to take a class or join a group in your community. Improv classes are offered through community education programs for both children and adults, at theatre or drama schools, by theatre companies and comedy clubs, and at community centers. Local theatre or arts advocacy organizations may have message boards advertising classes or improv groups that are open to the public.

If you are interested in starting your own improv troupe or if you would just like to experiment informally with a small group of friends, there are many books and websites that provide instructions on hundreds of exercises and games. Some of the best books to start with include Viola Spolin's *Improvisation for the Theater* and Charna Halpern and Del Close's *Truth in Comedy*. Augusto Boal's *Games for Actors and Non-Actors* describes over one hundred games. In the next chapter, I provide an outline for an hour-long improv session.

Theatre Classes

Theatre classes address every element of the field, from acting and singing to scenic design and playwriting. To find a theatre class in your community, look to organizations that offer continuing or

adult education, theatre schools, community centers, local theatre companies, and children's theatre companies.

Classes in the community are not all high quality, though, so how do you know what to look for? Ask the teacher or organization if you may observe a class meeting. Sometimes there are public performances or exhibits associated with specific classes or workshops. These may be referred to as "showcases" and open to the public. Search the internet for reviews of the class or the organization that hosts the class. Talk to current students to see what they think about the course. Major red flags include signs of bullying, bias, harassment, abuse, or favoritism, and attempts by unqualified teachers to engage students in exercises that resemble psychotherapy or dramatherapy. If you see evidence of any of these things, look elsewhere.

Certain theatre skills lend themselves to online learning experiences, although most theatre educators have resisted offering courses that do not involve the shared physical presence that is fundamental to most theatre. The recent global pandemic necessitated moving most theatre-based activities online, however, so there are now more options to explore. Playwriting courses are probably the most natural fit for online learning. The National Theatre's YouTube channel also houses a series of interviews with playwrights that focus on various elements of the art and craft of writing for the theatre, from plotting to character development. There are a number of theatrical design courses available online for free from Massachusetts Institute of Technology through MIT's OpenCourseWare. And more teachers of acting are now mastering the art of working in the online classroom. The primary downside of taking online courses in theatre is the lack of social connection. If it is possible to attend an in-person theatre class, that will usually provide you with a more complete experience – one that offers both the creative engagement and social connection that make theatre such a powerful tool to support health and well-being.

Community Theatre or Amateur Drama

The terms "community theatre" and "amateur drama" are broadly defined as theatre that is created by, with, or for a specific

community. Usually the terms describe theatre companies that rely primarily on the labor of local volunteer artists and technicians. Sometimes they have a paid staff and a permanent performance venue. They are typically not-for-profit ventures with a mission to serve their local community by offering opportunities for residents to participate in all aspects of theatrical production for the purposes of enjoyment and creative self-expression. Some community theatre (or "community-based theatre") is created by professional theatre artists in collaboration with members of a particular group. The intent of community-based theatre is to use theatre as a vehicle through which people can explore an issue, foster creative self-expression, or heal social divisions.

When a community theatre produces a play, it generally holds open auditions for actors and publicizes those auditions on social media platforms and local message boards. If you are interested in acting in a community theatre production, begin by identifying the companies in your area and check their websites. Some theatres maintain mailing lists and will notify you when auditions are upcoming and provide instructions about how to sign up for an audition spot. Community theatres are also in need of people who are interested in doing the important work that takes place behind the scenes: building sets, sewing costumes, hanging and focusing lights, or serving on stage crews during performance. So if you prefer to avoid the spotlight, there are still plenty of opportunities to get involved.

THINGS TO EXPERIENCE

Attend a Play

Seeing a play performed live and in person is an ideal way in which to experience theatre if you do not wish to participate in creating it. You can see a play on your own or with others. If you cannot see a live performance in person, an increasing number of theatres are streaming live and pre-recorded performances. For example, a recording of Lin-Manuel Miranda's hit musical *Hamilton* was made available to stream on demand during the summer of 2020. It was a delightful highlight to an otherwise difficult year.

Plays are performed at a wide variety of venues, from college campuses to professional theatres to community centers. If you are interested in seeing a polished performance with beautifully executed sets and costumes, look to professional theatre companies. The polish, however, usually comes with a high price tag. You may be able to find discounts or concessions for seniors, students, groups, or undersold performances. Check with the box office of the theatre to see what is available. Sometimes there are opportunities to volunteer as an usher in exchange for free tickets. Many universities and colleges have high quality theatre training programs and hold public performances that can rival professional productions. The cost of admission to these performances is generally low, and discounts or concessions are often available, too. Community theatre ticket prices vary quite a bit, from free or "pay-what-you-can" to the equivalent of the price of admission to smaller professional theatres. As always, check with the theatre company to find out about ticket pricing and special offers.

Post-show Discussions

Many theatres host discussions between the audience and either members of the creative team or subject area experts immediately following one or more performances of a show. The number of times such discussions are offered during the run of a production depends upon the theatre, its mission, and the show itself, but they are always offered free of charge. Information on the schedule for discussions will be posted on the theatre's website or you may contact the box office. Most post-show discussions offer audiences an opportunity to learn more about the play and to share their own responses to the performance. These events usually last about 20 or 30 minutes and provide opportunities to interact with members of the creative team and other members of the audience.

Back-stage Tours

Back-stage tours give members of the public an opportunity to see what a theatre looks like from the other side of the footlights, so to

speak. You may visit the scene and costume shops, rehearsal rooms, and stand on the stage itself. Your tour guide will be able to tell you about the history of the theatre and answer questions about how various technical elements of the theatre building work, such as fly lofts and hydraulic lifts. Hopefully they will have a few colorful (perhaps apocryphal) stories to tell about mysterious accidents associated with ill-fated productions or the odd pre-show rituals practiced by famous actors.

Play-going Groups

If you attend performances regularly, consider forming or joining a play-going group. This is similar to a book group, but the text the group "reads" and discusses is a live theatrical performance. If you are already part of a book club, you could even propose seeing a play instead of reading a book. A play-going group discussion is similar to a book club discussion. Here are some questions you can use to facilitate a discussion:

- What were your expectations of the play and were they met?
- What were your first (or last) impressions of the play?
- Were there any moments that particularly stuck with you? What were they and why did you find those moments so powerful?
- What is each major character's goal and what obstacles get in their way?
- Do they achieve their goals? How?
- How does the physical or social environment in the play influence the characters? When you reflect on these influences, does this change how you feel about particular characters?
- What do you think this play was about? What themes did the play explore?

If your group has also read the play in question, you can spend some time discussing how this particular production team

interpreted the play in performance. Some questions to explore include the following:

- Did the actors' performances fulfill your expectations of the characters?

- Did the sets, costumes, props, and lighting match what you had imagined? If not, how did your expectations differ from what you saw? What do you think about that difference?

- Did the performance change your understanding of or feelings about any aspect of the play? What were those changes? Why do you think the live performance had that effect on you?

- Did you learn anything new about the play by seeing it performed? If so, what?

Accessible Performances

Audio Description: Many theatres offer audio description services for their patrons. A trained audio describer provides live commentary on the visual elements of a production so that people who are vision impaired can engage fully with the performance. These descriptions are broadcast to patrons via a receiver and headset provided by the theatre, free of charge. Before the performance begins, some audio describers will prepare their audiences by providing commentary on the stage and costumes, appearances of the characters, and important props. Once the curtain goes up, describers try to speak between the actors' lines, providing information on character entrances, exits, and actions.

Sign Language Interpretation & Captions: Similar to audio description, many theatres offer live sign language interpretation during performances for patrons who are deaf or hearing impaired. Interpreters typically sit or stand to one side of the stage and are lit so that they can be seen. They interpret any sounds, music, or spoken language in real time. Other theatres offer captioning services at their performances, projecting a transcription of the spoken language and descriptions of sounds onto a surface near the stage.

Sensory-Friendly Performances: An increasing number of theatres offer special performances of shows for people with sensory sensitivities. During these performances, the audience lights are dimmed only slightly and sound effects are played at lower volumes. These may be called "lights up, sound down," "sensory-friendly," or "autism-friendly" performances. Audience members at these performances are allowed to move and vocalize in ways that would be considered unacceptable at a typical theatrical performance. Thus, they offer much less stressful opportunities for people with sensory sensitivities and their families or caregivers to enjoy an art form that sometimes feels off-limits to them.

If sensory-friendly performances are not available in your area, you might look to a children's theatre as an alternative. In theatre performed for children, there is an expectation that the audiences will be less inhibited than audiences composed mostly of adults. High-quality, professional children's theatre is a delight for all ages.

Recordings of Musicals

If you can't get to the theatre and you enjoy music, listening to a recording of musical theatre score is an excellent alternative. You may be able to find some in libraries, you can also download them to a digital music player, or you can purchase a CD. The songs in musicals often contain quite a bit of the show's plot, so if you listen from beginning to end in order, you will be able to get the gist of the story. You can usually find complete plot descriptions of major musicals on websites like Wikipedia. To find a musical, a quick internet search should yield lots of recommendations for the 10, 25, or even 100 "best musicals of all time." There are also many wonderful movie musicals, from the classic *Singin' in the Rain* to the recent biopic *Rocket Man*. In addition, many stage musicals have been adapted for the screen quite effectively.

SUMMARY

This chapter discussed some of the myriad ways in which individuals and groups can engage with theatre. These range from writing

a play to attending a class to watching a performance. There are options for everyone – for those who wish to take center stage and for those who would prefer to stay in the audience. And although some engagement with theatre can be quite expensive, like going to see a blockbuster musical on Broadway or the West End, many accessible and interactive options are also available.

4

WHAT CAN PROFESSIONALS DO TO HELP?

As I have suggested throughout this volume, theatre practices are highly adaptable. With a little imagination, health and social care professionals can provide opportunities for patients, colleagues, and community members to engage with theatre in hospitals, care homes, rehabilitation clinics, community centers, houses of worship, and schools. However, not all theatre activities are appropriate for all situations. To decide which technique to use, begin by clearly articulating the primary goal of the activity. Is it to build community, improve communication, develop self-efficacy, provide opportunities to engage in pro-social behavior, or simply to offer an entertaining distraction? The answer will help guide your approach. What follows is an overview of several methodologies that are accessible to people without theatre experience, although involving theatre artists and educators will enrich the experience. Where possible, I provide step-by-step instructions for those who wish to try an approach.

BEING IN THE MOMENT

Imagine that you are a young actor and you have just landed a role in a long-running show on Broadway or the West End. It's a dream come true and offers you a chance to grow as an artist. Now imagine it's six months later, you have performed the role seven times

this week alone (after having performed it dozens of times in the preceding months), and you've got another show tonight. Obviously, you could play the role in your sleep. But your audience has not heard these lines before and is expecting a captivating night at the theatre.

How do actors make it seem as though they are saying these lines for the very first time, even when it's the hundredth time? This is an essential part of the actor's job, and, in the theatre, we refer to it as "being in the moment." That is, each time an actor plays a scene they must do so as though this is the first time they are speaking these words and experiencing the events that are happening to their character. The actor cannot anticipate what is going to happen at the end of the scene; instead they must remain fully present in the thoughts and feelings of the character in the now. In a very real sense, this is an exercise in mindfulness. Art therapist Amy Bucciarelli (2016) argues that "[i]ntentional art-making ... mirrors other evidence-based techniques, such as mindfulness-based stress reduction (MBSR), which prompts body awareness and a focused, non-judgmental mind." The actor must attend to the present moment instead of letting their mind wander to the previous scene or the next or to the shopping they need to do for dinner after the performance is over. Instead, they must carefully observe what the other actors are doing and respond to those actions in character.

There are few more useful skills for caregivers than being in the moment with another person. Be it a physician taking a history from a patient or an actor doing a bedside performance for a hospitalized child, attention must be paid to the whole person to whom care is being provided. Attending to what that person communicates – through words or gestures, facial expressions or silence – requires being profoundly in the moment with them. Instead of anticipating answers or making assumptions, this technique demands slowing down and observing what is happening. It also opens a space for the caregiver to develop awareness of their own state of being. Heightened awareness of self and others prepares us to respond with what is needed here and now.

What You Need

A quiet place to sit | A chair, stool, or, if you prefer, just a pillow on the floor | About five minutes.

Methods

- If possible, take a seat with your feet resting flat on the ground. If you prefer, you may also sit on the floor. What is important here is that you are able to sit relatively upright. Close your eyes and take a few deep breaths, slowly inhaling through your nose and exhaling through your mouth. When you inhale, your diaphragm pulls down on your lungs. Allow your belly to soften so that it rises and falls with your breath.

- As you breathe, conduct a quick mental scan of your body, from the crown of your head to the tips of your toes. How does your body feel? Do you notice tension anywhere? Can you gently release that tension? If not, just notice it is there.

- Continue breathing and notice the seat or floor underneath you, your feet or crossed legs touching the floor, the temperature of the air on your skin, your clothes touching your body. If you notice your mind wandering, gently steer your attention back to your breath.

- If you have more than just a minute to get "in the moment," you can extend this exercise by shifting your attention to specific elements of your environment (sounds, smells, visual stimuli, etc.), returning your attention to your breath when your mind wanders.

Some people develop a little ritual that helps them to get into the moment. Before entering a room to meet with a patient, for example, a healthcare provider might deliberately note the feel of the door knob under their fingers and take a few deep, slow breaths before opening the door to begin the encounter. The whole process would take only a few seconds, but it provides an opportunity to center and focus attention on the present moment.

YES, AND

In the specific context of theatre for health, the cardinal rule of improv, "yes, and," is fundamentally an affirmative, strength-based approach to building trusting, creative relationships. Actors use improv frequently in all types of theatre practice but it is also an extremely useful tool for both professional and informal caregivers (family and friends). Anyone who has interacted with a person living with dementia knows that the world perceived by them does not always match the external realities. Attempting to correct these misperceptions is usually futile and often counterproductive. Taking a "yes, and" approach can support a pivot away from arguing over a false belief and toward a positive interaction. For example, imagine a person with Alzheimer's becoming agitated because they believe that they need to go home even though they are, in fact, at home. Instead of trying to explain the reality, you could agree to take them home. This might mean simply going for a short drive or a walk together. The key is offering an affirmation of their sense of the world ("yes, you want to go home because this place feels unfamiliar to you"), and then providing safe ways to honor their desire for agency ("and, let's do something about that by going 'home'"). Another way in which to use improvisation to flip the script on a challenging encounter is to find a way to exit the "scene" and then start over again after a brief "intermission." If a patient with dementia won't cooperate with, for example, taking their medicine, you can end the encounter by leaving the room for a few minutes. Then return and try again. Sometimes changing an item of clothing or adjusting the energy with which you enter a room can make a difference in achieving willing cooperation. Or find another caregiver to enter the "scene" and take it in a new direction.

Learning to say "yes" to something that very clearly does not align with the reality we perceive is hard. With a little practice, it is possible to disrupt the instinct to correct errors in perception and instead take a moment to think about how to build on the foundation this person has offered you. It doesn't need to be an elaborate response involving flights of fancy. The point is to acknowledge and affirm what has been expressed and to build on that offering in an appropriate way.

You may need to try out a few different approaches before you find a response that works for your situation, but bringing a flexible, playful approach to your caregiving practice can also help ease stress on the relationship between you and the person to whom you offer care. In addition, it can help you stay present in the moment with that person.

REHEARSED READINGS & READER'S THEATRE

The basic practices of both rehearsed readings and reader's theatre are the same: a group of people read a relevant text aloud together. Rehearsed readings and reader's theatre differ primarily in that the latter often utilizes non-theatrical texts, such as memoirs and short stories, and the "readers" are usually not professional performers. In addition, reader's theatre may not involve an audience outside of the group doing the reading. In a rehearsed reading, there is always an outside audience. In health and social care settings, rehearsed readings and reader's theatre are used frequently as tools to support instruction in the ethical, emotional, or relational aspects of care (e.g., Langlois et al., 2017). They have also been used to provide culturally respectful ways to explore sensitive topics like cancer in public health education efforts (e.g., Cueva, 2010). The prism of the dramatic fiction can provide participants with just enough aesthetic distance to discuss topics that might be considered taboo or emotionally fraught. In addition, they are used to build community and provide opportunities for creative engagement and entertainment.

In both rehearsed readings and reader's theatre, roles are assigned to members of the group and, if the text is a play, a "narrator" reads the stage directions aloud. When a public audience attends a reader's theatre event, there is usually at least one rehearsal to help orient the performers to the text and the experience of public presentation. However, the emphasis of reader's theatre is less on performance than on the facilitated discussion that accompanies reading the text. Such conversations encourage participants to reflect on particular ideas that support the learning goals of the

session.[1] Both rehearsed readings and reader's theatre are presented without the support of sets, costumes, and props, and actors are not required to memorize their lines because they will read directly from the script during the performance.

If your group is comprised of people with little or no performance experience and will perform the reading in front of an audience, hiring a theatre educator to direct the reading is helpful, though it is not absolutely necessary. The cost of such an investment will vary, but it should not be exorbitant. In addition, a good theatre educator will provide opportunities for members of your group to develop their creative skills. Check to see if the educator has experience working with people like the members of your group; rehearsal techniques vary quite a bit depending upon the demographic of participants.

Rehearsed readings and reader's theatre events are among the most easily produced forms of theatrical performance, but they do require some advance planning. To facilitate your efforts, I provide step-by-step instructions below.

What You Need

Permission to read the play in front of an audience | Copy of the script for each actor | Space for your audience and actors to sit | Music stands (optional) | Time (3–6 hours minimum) | Participants (variable number, depending upon script and group goals).

Methods

1. *Pick a play that suits your purpose and is appropriate for your performers and audience members.* Is your goal to provide a fun diversion or are you using the reading to launch a serious discussion? Consider your performers' previous exposure to

1. A note of caution: If you do not provide participants with the script in advance, there is significant risk of "outing" participants with learning disabilities, social anxieties, or other individual situations that have an impact on reading aloud. Therefore, it is wise to allow participants to volunteer to read parts.

theatre. Are you engaging professional actors, or will you be soliciting volunteers from your community? If you need assistance finding a good fit for your group, librarians are excellent resources.

2. *Secure the performance rights.* If you are reading the play in a private setting without a public audience, then you need not secure performance rights. But when the public is involved, you must get permission to perform the play (or any other original work, i.e., not in the public domain) from the copyright holder even if you do not charge an admission fee. Typically, one must pay for the right to perform a copyrighted work in public; fees vary depending upon factors like the size and location of the performance venue and the genre of the piece (e.g., popular musicals often come with hefty fees). If you are not sure whether the play you have selected is protected by copyright law, check with a local librarian.

3. *Assign roles to actors.* Determine the number of actors required to read the play aloud, including someone to read stage directions. Depending upon the size of the group and the number of parts in the play, you may ask more than one person to take turns reading a single role, or you may ask a single actor to perform multiple roles. If you have engaged a director, work with them on this task.

4. *Provide copies of the play to each actor.* If there are different versions of the script available, make sure everyone is using the same version (some versions are surprisingly different!). Secure and number loose pages to prevent disaster during performance.

5. *Rehearse the play at least once.* The first rehearsal usually focuses on reading through the play aloud together, understanding what happens, who the characters are, and which stage directions must be read aloud to ensure audience comprehension – this is usually determined by whoever is directing the play. Additional rehearsals allow actors to develop more fluency and confidence with their lines and offers opportunities for them to develop stronger characterization. Make sure actors know where they will sit during the performance.

Typically, actors in rehearsed readings sit in chairs facing the audience and rest their scripts on music stands.

6. *Decide on the timing of intermission.* If you are reading a full-length play, plan to have at least one break about halfway through. The person reading the stage directions is usually the best person to announce the beginning of an intermission.

7. *Introduce the event.* Take a moment to welcome your audience and introduce the reading. You might tell the audience a little bit about the play or the playwright and how it relates to something important to your audience. Or you might tell your audience about how this reading came about. The point of this type of introduction is to orient your audience and focus their attention in the right place for your purposes. If you plan to have a discussion after the reading, let your audience know this by saying something like, "When the reading is over, we will take a short break and then have a discussion about the play. We hope you can join us."

8. *Invite the actors to take their seats on stage.* If you are working with individuals who have restricted mobility, you might consider having all the actors take their places on stage *before* the welcome and introduction.

9. *Begin the reading.* The actor assigned to read the stage directions should read the title of the play, the name of the playwright, and set the scene with any introductory stage directions. These usually describe the setting and characters and help orient the audience to the world of the play.

10. *Take a bow.* When the reading is over, allow your actors to take a bow, or otherwise welcome and enjoy applause. Thank the audience for attending, and, if there is going to be a discussion, remind them that it will take place after a short break. A break of about two minutes will allow people to leave or get situated without disrupting the flow of conversation.

11. *Discuss the play.* Thank your audience for staying and briefly introduce anyone you have invited to speak about

the play or the subject matter. The facilitator's job is to keep the conversation flowing and productive, which requires the advance preparation of five or six questions for a 20- to 30-minute discussion. To break the ice, begin with a prompt that allows quick, specific responses from the audience. For example, you might ask, "What's one word you would use to describe how you feel after experiencing this play?" There is no wrong answer to this question, which encourages participation. One-word answers allow many contributions in a short period of time. When about five minutes of discussion remain, let the audience know that there is time for just a few more questions or comments. Close your event with thanks to any panelists and to the audience who chose to stay for the discussion.

CREATIVE STORYTELLING

Anne Basting, theatre artist and founder of TimeSlips™, uses improv's "yes, and" philosophy to engage people with moderate-to-severe cognitive impairment in collaborative storytelling activities. In each session, a facilitator presents a visual stimulus to the group, usually a photo carefully selected to be evocative of a story. The facilitator then poses a series of simple questions designed to build a narrative about the photo. Some participants are hesitant at first because they are afraid of being "wrong." But with support and reassurance the narrative details begin to emerge. To affirm what each participant has contributed (the implicit "yes"), the facilitator or an assistant writes down *exactly what each participant expresses* on a surface that everyone can see (e.g., a whiteboard or a large notepad propped up on an easel). Precise documentation communicates the value of the participant's offering and the intention behind it. Each additional contribution to the story forms its own kind of "and" in the spirit of improvisation.

After a TimeSlips™ event has concluded, Basting encourages facilitators to share the end product with others. Certified facilitators will, at the very least, type up what was written and publish it to the TimeSlips™ website. But the sharing of this work is really only limited by the imagination and access to modest resources.

Finished stories may be printed and put on display in a care home or collected in a book along with other works of art created by residents and staff. Professional artists can be commissioned to create art work in conversation with the stories, which might then be exhibited for residents, staff, friends, and family. A theatre group may use one or more stories as the basis for a live performance piece that is shared back to the community at a live performance event. The point of this final step is to honor the creativity and contributions of the participants. Publicly acknowledging participants' strengths and abilities as evidenced by their creativity and imagination can help reduce the stigma associated with cognitive impairment.

What You Need

Space (a room in which participants can be seated and can see the story as it is written down, ideally in a semicircle) | Supplies (a white board or an easel pad; colorful, thick-tipped markers; name tags; multiple copies of the image you will use as a prompt) | Participants (about 10, plus a few staff or volunteers to assist).

Methods

1. *Before the session, meet with the staff of the care home* to explain what you will do with participants, describe any support that you might need (e.g., setting up chairs), and request that other activities be scheduled before or after the session (e.g., administering medications). Ask them to turn off televisions and music during the session.

2. *At the start of the session, provide name tags to all participants.* Ask the staff to help you with this task.

3. *Greet each participant by name* and with a handshake or other friendly touch, if appropriate.

4. *Welcome the group* and tell them that you are making up a story together for fun.

5. *Show them the picture you will use as a prompt* and distribute copies to everyone.

6. *Pose open-ended questions about the picture.* For example, if the image includes a person or character, ask the following kind of questions: What would you like to name this person/character? What shall we call her? The questions you ask should guide participants to supply details about the world of the story and what is happening in and around the picture – who, what, where, when, and why questions. Other example prompts include: Where should we say this story takes place? When shall we say this story takes place? What sounds do you hear? What happens next? What is this person or character like? What do they hope for?

7. *Affirm all participant responses.* Echo and write down all responses on the easel pad or white board exactly as expressed by the participant. (Having someone else to transcribe the answers is extremely helpful.) If the response is non-verbal, like a hand gesture or a vocalization, the note-taker should document it as accurately as possible. Staff or volunteers can help out by repeating answers for the note-taker. Sometimes it is hard to keep up with all the responses!

8. *Periodically review the story.* Every now and then, stop and read the story aloud from start to finish. When you read it to the group, have fun with it. This is your moment to lift the story off the page with an energetic and fully committed performance.

9. *Finish the story.* Find a way to bring the story to a close and read the whole thing aloud one last time.

10. *Thank the participants*, individually if possible, and acknowledge their various contributions to the storytelling experience. Tell the participants and staff how you will be sharing the story with others.

To access appropriate images for a creative storytelling session of this kind (visit www.timeslips.org/resources/creativity-center/make-up-a-story).

IMPROVISATIONAL THEATRE WORKSHOP

In the previous chapter, we discussed improvisational theatre as a genre. If you would like to offer an improvisational theatre workshop in your health or social care community and you have the resources, securing the services of a theatre educator who has worked with a similar population is ideal. However, if you cannot hire such an instructor, here is some guidance on how to get started.

Before an improv session, determine which games and exercises are appropriate for your group and how you will adjust them, if necessary. A successful session is built on trust, which must be developed through activities that bond members to one another. In addition, successful sessions offer both challenges and opportunities for mastery. The opportunity to complete something difficult, like a theatre game or exercise, and develop skills in the process can result in a sense of accomplishment. Most activities can be adjusted to account for the skill level of the group. So, start simply and add more complexity to the games as participants begin to grasp the rules.

What You Need

Space (a private room with plenty of space to move around and furniture that can be moved easily, e.g., multipurpose room, gymnasium, dance studio) | Time: about an hour, but you can adjust as needed | Participants: 6+.

Methods

1. *Set agreements or ground rules with your group.* Keep these short and simple. Above all, ground rules are intended to keep participants safe from harm, and should be appropriate for the needs of *your* group (e.g., a support group of adults in alcohol or drug recovery might agree that participants will be substance-free on the day of a session).

2. *Ice breaker*: "The Name Game." As the title suggests, the goal of this game is to learn the names of everyone in the group

through play. Members of the group stand in a circle facing toward the center. *Level 1:* Start the game by saying your own name and then point to someone else in the circle. The person you pointed to should say their name and point to someone else. Repeat this pattern until everyone has heard everyone else's name several times. *Level 2:* Keeping the energy and focus moving, when each person points, they must say the name of the person *at whom they are pointing.* If someone forgets or says the wrong name, the person being pointed at should politely offer their name and then move on to point at and name the next person. There are additional complications that you may wish to add in, but these two are usually a good place to start (Gwinn, 2003).

3. *Energy and focus game:* "Zip-Zap-Zop." This is a classic of the improv world and has many variations. The simplest version is played as follows: Standing in a circle, someone (we'll call her Sue) begins by simultaneously saying "zip" and pointing with both hands clasped together at someone across the circle (we'll call him Frank). Frank then says "zap" while pointing with both hands clasped together at a third person (Payton). Payton then says "zop" while pointing with both hands clasped at a fourth person. The zip-zap-zop sequence repeats, moving around the circle at random. The goal is to say "zip-zap-zop" in the correct sequence (which is harder than it sounds) at a consistent pace (also harder than it sounds). As the group gets more confident, they will get faster (see Gwinn, 2003 for additional variations).

4. *Creative game:* "Super Chair." This is a game in which participants imagine new ways to use or interact with everyday objects. Participants sit in a circle. Place an object in the center of the circle and invite everyone to take a turn interacting with the object in a way that contrasts with its real purpose. The way each person interacts with the object communicates what the object's new purpose is. For example, the handset and cord for an old telephone could become a lasso if an actor swings it around like a rope. A scarf could

become a snake. You may allow participants to use sounds and speech or require them to do the exercise in silence (see Swale, 2017).

5. *Creative game 2 (time permitting)*: "Word-/Line-at-a-Time Story." In this game the group quickly invents a story together, either by adding a word at a time, or a sentence at a time.
 If you choose to build the story a sentence at a time, it is help-ful to have the speaker end their sentence by adding, "And then…" to cue the next person. Encourage participants to offer whatever comes into their heads. They don't need to overthink what they say, though they should be trying to form sentences that can be understood and that connect to what the other storytellers have offered (see Swale, 2017 for additional detail).

6. *Debriefing*. Leave a little time at the end of your session, per-haps five minutes, to allow participants to discuss their experi-ences and what they discovered. Tailor questions or discussion prompts to the goals of the group.

7. *Closing ritual*: "The Power Clap." Standing in a circle facing one another, everyone executes a single, loud clap in unison.

TECHNIQUES TO USE IN COLLABORATION WITH THEATRE ARTISTS

The techniques below require more experience, particularly if you are working with a vulnerable population or with a community of novice theatre-makers. However, all of these approaches have been used successfully in health and social care settings; therefore, I include a brief description of each methodology to give readers a sense of what is possible when members of a health or social care community collaborate with theatre artists.

Rehearsing and Performing a Play

Rehearsing and performing a play is a time- and resource-intensive process, and the methods required exceed the scope of this book.

But it *can* yield significant benefits for participants and other members of the community, as is evident when one considers the benefits associated with a program like SENSE Theatre® (as discussed in Chapter 1). If you wish to mount a full production of a play for the purpose of improving health and well-being, gather a multidisciplinary team that includes theatre artist-educators as well as people with the expertise to support the needs of your participants.

Devising a New Play

Just as engaging in the rehearsal process for a pre-existing play can be an empowering experience, so, too, can contributing to the creation of an original performance text. Participating in a creative process that is led by skilled facilitators offers mastery experiences that can boost self-efficacy, build a positive self-image, and develop a sense of autonomy. Theatrical "devising" is a collaborative approach to writing a new play. Devising is, by definition, a flexible process that can accommodate the abilities of many different people and incorporate their contributions in various ways. There are many different approaches to devising, but they often include developing a script based on improvisation, text-based research, or interviews (the case study on Reminiscence Theatre in Chapter 2 provides one example). In some cases, plays are generated through a rigorous research process based in ethnography, social science, or history. This type of script is sometimes called "research-informed drama" or "ethnodrama" (Saldaña, 2005).

Interactive Theatre

The term "interactive theatre" indicates any type of theatrical performance in which the division between performer and audience member is blurred. Although some interactive theatre does not require professional actors, the successful execution of interactive theatre usually involves collaboration between theatre artists with some experience in this domain and health care, social care, or public health professionals experienced in working with the target community. In addition, adequate time must be allotted to the preparation of a meaningful

interactive theatre experience. A script of some kind must be developed[2] and actors need time to rehearse both the scripted text and, more importantly, the improvisational interactions that will be required of them.

Clowning

No discussion of theatre in health and social care settings would be complete without some mention of clowning. The clown's tendency to make mistakes and to reveal internal emotional states that others might choose to hide, make them vulnerable, and lower their social status in relation to others. Perhaps this is why clowns make such excellent foils for some of the most vulnerable members of our society: sick children and elders with cognitive impairment. Through their performance of low-status characters, medical and relational clowns can elevate the status of the people with whom they interact.

Medical clowns (also called clown doctors or therapeutic clowns) are professional performers who use their artistry to distract and support children through play and fun during specific medical procedures or stays in hospital. Some hospitals have integrated medical clowns into their multidisciplinary care teams. The Dream Doctors, for example, work in 29 hospitals all over Israel, serving over 200,000 patients each year. Dream Doctors undergo five months of formal training before they are allowed to perform on the wards, and they work regular shifts, just like any other member of a care team (dreamdoctors.org.il). Although it may seem that the medical clown's job is simply to distract a child long enough to complete a painful or frightening procedure, the clown also offers children opportunities to exercise agency and imagination, experience wonder, joy and (when appropriate) laughter, and focus on something other than the condition that has led to their hospitalization. Medical clowns tailor their performance and select appropriate activities to meet the specific needs of each child referred to them by the medical staff (Ford et al., 2014).

2. This is where collaboration between theatre artists and health and social care professionals is essential.

Clowning is also employed successfully in care homes, particularly for people living with dementia. Elder clowns or relational clowns, as they are often known in care home settings, are skilled professional performers who specialize in creating meaningful social connections with elders and offering them opportunities to engage in aesthetic pleasure of various kinds. Interestingly, relational clowns often work in pairs, rather than solo, as medical clowns typically do.

When considering engaging relational or medical clowns in a social or healthcare space, organizations must be prepared to weave them into the fabric of the care team. To do their jobs well, clowns in health and social care settings require accurate, relevant information about the people with whom they work. In addition, they need to understand the care team's goals for the interaction. Conversely, health and social care professionals also need to understand a little bit about what clowns have to offer and how they can do their best work. When successful, the positive impact can extend beyond the person with whom the clown directly interacts to other formal and informal caregivers.

SUMMARY

This chapter examined some of the ways in which theatre can be employed in health and social care settings, with or without the support of theatre artists and educators. Practices that are fundamental to the craft of acting, like "being in the moment" and "yes, and," have the advantage of being extremely accessible and adaptable to different environments. Readings and creative storytelling sessions require more advance planning, but they can and have been executed very successfully by health and social care professionals in various settings, from care homes to community centers. To support those who wish to try their hand at some of the techniques discussed, instructions have been provided where appropriate.

If you are considering bringing theatre into a health or social care setting, or employing theatre as part of a public health initiative and you have the resources, engage an experienced theatre artist or educator to help identify the appropriate theatrical tools

to meet program goals. Once an approach has been identified, employ an artist with the requisite skills and relevant experience to facilitate the activity. Although your intentions may not include creating a professional product, a theatre artist or educator can ensure that participants are engaged in a rigorous, high-quality artistic process. Theatre artists are typically able to execute the work more efficiently and effectively than someone without the requisite background. However, if engaging a theatre specialist to support your efforts is not feasible, there are many useful resources that offer detailed guidance on planning and executing a variety of theatre activities that can be tailored to your needs (see Chapter 6).

And, of course, there are perhaps the two most important theatre practices everyone can cultivate: saying "yes, and" and living "in the moment" with others.

5

WHAT ARE THE CHALLENGES AND OPPORTUNITIES?

Although theatre is a highly versatile activity with which humans have engaged for thousands of years, we will now discuss certain contemporary barriers to successfully introducing theatre in health and social care settings. Below are some of the most common challenges to face and strategies to deal with these when attempting to integrate theatre activities into health and social care settings. Obviously, each situation is unique, so you may experience challenges not included here. However, open conversation among collaborators and advance planning ease many difficulties.

GENERAL PUBLIC

Time

We all understand that many people are extremely busy and that time is a valuable resource. When planning a theatre activity of any kind, carefully consider the specific time-based limitations of the population with whom you are working. In theatre-speak, you must "know your audience." You will need to strike the right balance between presenting theatre as fun, educational, or good for you. In the context of the latter, typically you achieve your goals for health or educational benefit and then, if there is time left over, do something fun or relaxing for its own sake. It is important when

planning theatre for health activities to anticipate and ameliorate
the time-based pressures on the community or individuals invited to
participate. Are you working with school-aged children, employed
adults, or residents of a retirement community? What are the partic-
ular demands on this community's time? Do not make assumptions.
Instead, consult with individuals in the community or others who
are familiar with it. Their insights can provide valuable informa-
tion. When you understand the demands on people's time, you will
be better able to design activities that fit into their lives.

<div align="center">Money</div>

Like time, money is a limited resource. This is often especially true
among the people excluded in society who could most benefit from
arts engagement. Therefore, you cannot assume that your intended
participants will have the disposable income to spend on tuition
for a class or admission to a show. Likewise, even if you offer the
activity free of charge to participants, you will need to consider the
hidden costs for them of joining in. These might include lost wages
due to missing work, childcare, or travel costs. These can make
participation prohibitively expensive.

Perhaps you can offer help with this by including support for
childcare, arranging ride-sharing, or covering expenses for travel.
Should you apply for financial support for a project these kinds
of costs can be factored in. If participants will be out of pocket
by their involvement, especially for participants performing for
the public, then you may be able to negotiate or plan for some
kind of reimbursement for their time. This is important as it shows
respect for their contribution. For professional participants, a paid
arrangement can prove a valuable credit on their professional CV
or resume.

<div align="center">Location</div>

If you build it, will they come? It depends on where you build
your program and how accessible it is to your potential partici-
pants. In order to determine the optimal location for your theatre
workshop, you need to get to know your participants. Consider

not only the space requirements for your planned activities, but also the geographic location of the space in relation to the people with whom you would like to work. In general, it is much easier for one facilitator to travel to a group of participants than it is for multiple participants to travel to a single facilitator. You may need to compromise on the amenities of the space itself, but this approach significantly reduces the travel burden on participants.

Beliefs

Personal and cultural beliefs may constitute barriers to participation in theatre workshops. Many people believe they are not qualified to participate in theatre activities because they lack experience. They also may have a limited understanding of what it means to engage with theatre; they may imagine participation necessarily means memorizing lines and performing in front of scores of people. For many of us, this is not an attractive proposition! Others may believe that participation in theatre is not useful or valuable to them – they may think of it as "just playing" and therefore a waste of time. Still others may have spiritual, religious, or cultural beliefs that create barriers to participation. For example, some people may consider there is moral danger inherent in playing characters who are less than exemplary in their conduct. They may believe that the imitation of bad actions on stage or screen can desensitize actors and audience members to the negative consequences of those actions and therefore lead them astray.

Instead of setting out to change personal or cultural beliefs about theatre among potential participants, it is probably more productive to find ways to work with those beliefs. For anyone who declares they are not an "actor," it can be useful to discuss the ways in which we all perform roles every day (e.g., as colleagues, friends, parents, children, and patients) and in a variety of settings (e.g., work, school, home, and hospital). In the language of theatre, these "given circumstances" influence our behavior, style of speech, dress, and even our feelings. We do not behave in quite the same way at work as we do at home or in a doctor's office. We dress differently when going to meet with the boss than when going to the gym. Recognizing that we all perform in our everyday lives can

be reassuring to anyone who enters a theatre workshop believing that they "cannot act." They know how to act because they do it every day already.

If you are working with a community holding spiritual or religious beliefs that create barriers to participation in theatre, it may be worth doing some preliminary research. Learn about the performance traditions of that community, particularly ones that relate to storytelling. How does the community make sense of events through story or narrative? Eurocentric cultures have an understanding of what constitutes "theatre" that is based on the dominance of Aristotle's theory of drama as interpreted primarily by Christian theologians, philosophers, and dramatists in the middle ages and the Renaissance. In Aristotelian drama, we emphasize the plot – what happens on stage – and expect that the story enacted through characters will contain a beginning, middle, and end. Language, spectacle, and music all contribute to the storytelling; in combination with the plot and characters, the whole piece may point to larger ideas or themes. Other cultures have different theatrical traditions that value different elements of live performance. Find out what elements of performance the community emphasizes or values and why this is the case. I am not suggesting that you will require a theatre for health facilitator from the particular community you are serving, but understanding its shared values and how these have manifested themselves through one or more performance traditions can help in the design of activities. Facilitating cross-cultural understanding through arts engagement can also constitute an activity in itself. If you are working with people who have intimate knowledge of their community's performance traditions, make space for them to be the experts in the room. Learning from the people you are trying to serve validates their knowledge and expertise and communicates respect for their culture and experience.

Fear

A significant emotional barrier to participation in theatre activities is fear. Some people fear performing in front of an audience, experiencing anxiety that can bring physical and mental distress. Some

people are afraid because they have never engaged in theatre activities before. Still others believe that participating in theatre activities will make them look foolish, and that they will experience a loss of face or social status as a result. Fear can manifest itself in a wide variety of ways, from being withdrawn or aloof to excessively sharing personal information to win people over.

There is little to gain from forcing the participation of someone who is extremely fearful or reluctant to participate in an exercise. However, a variety of techniques can reduce fear as a barrier to participation. The following are worth trying:

- *Scaffold activities*. Start any session with simple activities that make people feel successful when they participate. Add complications as competence increases to maintain interest or to generate communal laughter and address fears or release tension. When people feel successful, they are more willing to try increasingly difficult tasks.

- *Meet them where they are*. Sometimes, particularly when working with adolescents, you may encounter a person who simply refuses to participate. Allowing participants to opt-out of an activity is important in the context of theatre for health. Choice offers people compromised by their identity as patients, children, or a member of another vulnerable or marginalized population the opportunity to exercise autonomy. Make an assessment based on the specific context of your group.

- *Establish agreements or ground rules* with participants to ensure a shared approach to appropriate or inappropriate behavior in the theatre workshop setting. Ground rules can be reassuring if they are clear, simple, and apply to everyone.

- *Provide a schedule*. In general, people like to know what is coming next, while uncertainty about the future typically causes anxiety. Although the element of surprise can be a useful tool when a storyteller wants to heighten tension, it is rarely productive in the theatre workshop setting because it reduces participants' ability to focus on the present. Providing an outline or schedule of activities to participants is a simple and effective way to reduce anxiety associated with uncertainty

about what happens next. For some populations you may not want to provide specific times for each activity. If the group goes off schedule, this may cause anxiety about running late.

- *Offer reassurance.* The fear of looking silly or "doing it wrong" are all too common among young people and adults engaging in theatre activities. Regardless of the root cause of the fear, facilitators can reduce participants' anxiety about failure or ridicule with several types of reassurances: (1) When everyone looks ridiculous, no one looks ridiculous! Some of the activities they will do might feel silly or make them seem ridiculous out in the "real world," but in the theatre classroom, where everyone is engaged safely in the activity, no one person can be the subject of ridicule (and therefore lose status) because everyone looks equally silly. (2) Mistakes are good! Mistakes mean you are pushing yourself in new ways, and that you are learning, which is exactly where you should be when you engage in a new theatre activity. No one does everything right the first time. (3) It's only theatre! We are here to have fun and try some new things; if we mess up, the world will not end. In other words, the stakes are low, so what do you have to lose?

Inappropriate Behavior

Any time we enter a new setting, we must learn the unwritten rules of the social contract that exists in that environment. If we do not know the rules, our behavior may appear to be "inappropriate." In theatre, there are different sets of rules or conventions that apply to different groups. Audience members comply with one set of rules (e.g., sit quietly during the performance, switch off mobile phones, applaud at particular intervals), while theatre-makers adhere to another set of rules that structure behavior in rehearsal and performance spaces (e.g., arrive at rehearsal on time or early, don't touch anyone else's props). When facilitating theatre for health, do not expect that your participants will know the unwritten rules of theatre spectatorship or participation. Instead, plan on spelling out behavioral conventions or expectations. For example, instructors might not realize that their students are unfamiliar with live theatre until *after* they observe

the students engaging in inappropriate behavior during events. Even graduate or professional students might not be experienced arts consumers; prepare students by introducing the specific conventions of appropriate behavior in advance. In some cases, it may be appropriate to adjust the environment or expectations to accommodate the needs or cultural expectations of the community you are engaging (see, e.g., the description of accessible performances in Chapter 3).

Other types of inappropriate behavior can erode morale. In his book *Group Improvisation,* Peter Gwinn writes that good group morale is only possible when "each member feels excited to be a part of the team, feels like they belong to the team, and feels like an important part of the team." When a group member does something that violates trust, it hurts morale and compromises the ability of the group to engage in its best work. Violations of trust most often occur when a member deliberately disregards a group agreement, makes a choice that puts others at risk of physical or psychological harm, or shares judgmental (rather than constructive) opinions about the contributions of other members. As Gwinn points out, it is much easier to build morale than it is to *re*build it. Therefore, it is well worth spending time cultivating trust among group members at the very beginning of any theatre engagement. There are many trust-building exercises in books about improvisation, theatre games, and devising for theatre (see Chapter 6). In the event that inappropriate behaviors compromise morale, one can return to these trust-building exercises as well as to group agreements or ground rules. Referring back to the social contract to which members agreed at the outset of an activity can provide an objective measure of behavior.

PROFESSIONALS

Time

Although many of the specific pressures are different between the public and professional worlds, time is a particularly precious resource for those working in professional health and social care. Professional caregivers, including physicians, nurses, and social workers, often engage with large numbers of patients or clients.

When a well-meaning practitioner of theatre for health offers their services in support of a particular population, the immediate response is often a blunt "no." The idea of adding something else to a health or social care professional's list of things to do may feel overwhelming to them. Furthermore, although theatre can be useful in training health and social care professionals, licensing bodies may impose restrictions that make it difficult to add content to the curriculum of training programs.

However, theatre for health activities, when designed thoughtfully and guided by an experienced practitioner, can help relieve time-related pressures on health and social care professionals. Take, for example, the busy schedules of most medical or health sciences faculties, who have clinical, teaching, and administrative duties, not to mention the need to keep up with the latest developments in their fields of practice. It may be possible for theatre for health professionals to lighten their load by teaching interpersonal communication skills to their students. Acting teachers can be extremely efficient in this domain because, as noted in Chapter 2, providing "playable" feedback to people about their observable behavior is their area of expertise. They can quickly "diagnose" or assist in identifying communication difficulties and offer learners individualized strategies to overcome them. Therefore, health and social care professionals might be able allocate certain specialized duties to theatre for health practitioners.

Money

The bad news is that theatre engagement always costs something. The good news is that one can usually achieve a lot with modest funding, and there are an increasing number of sources of financial support for arts for health programming and projects. If you plan to bring theatre into your health or social care setting, it is best to pay for the services of established theatre artists or educators. If you cut costs by soliciting only volunteers to support your theatre for health activity, it is unlikely that you will secure the experience, specialist knowledge, and meaningful support required. Theatre artists are professionals with substantial training and worth paying for their expertise. This is important given that many theatre for

health artists and educators are subject to the so-called gig economy. As with any other profession, their skill set deserves appropriate, meaningful compensation.

Where do you find money to support theatre for health activities? Grants may be available from local, regional, or national arts councils, charitable organizations that serve special populations or target particular needs, and private foundations. If you wish to seek funding, start with a small-scale pilot project that will allow you to prove that you can execute your plan, gather preliminary information on its impact, and make a bid for additional support of a related but more ambitious project. Make links with leading academics with a track record of securing funding for research in the arts. You or your theatre organization may be fundable as a partner of a research enquiry. If you work in an institutional setting, like a hospital or care home, you may be able to request seed funding, especially if you are able to link theatre engagement to an institutional goal. For example, hospitals, professional organizations, and care homes around the world have successfully used theatre to address bias and stigma with the ultimate aim of improving patient care. If you manage to secure funding from the institution for which you work, create an evaluation plan so that you can track the successes and understand any failures of your theatre for health activities. For guidance on evaluating theatre for health activities, see Daisy Fancourt's 2017 book, *Arts in Health: Designing and Researching Interventions.*

Beliefs

Unfortunately, people in many parts of the world may consider the arts as a luxury. Despite its central role in human development, some will deem it "just play." In professional healthcare settings, a major challenge to incorporating theatre for health is the commonly held belief that theatre has little utility or value in promoting health and well-being. When professionals do not understand the impact theatre can have on health and well-being, they will not make space for it in their budgets or schedules. This is understandable given their priorities. However, innovative health and social care providers are turning to theatre as a cost-effective approach, drawing on

the kind of evidence outlined in Chapter 2, which indicates benefits
for health and well-being.

Fear

Fear can also be a significant challenge to the integration of theatre
in professional health and social care settings. Professionals may be
concerned that participating in a theatre activity will diminish their
social status in relation to others. For someone who is an expert
in a particular field, it can be quite humbling to try something new
and risk feeling or seeming "incompetent," especially when their
professional role requires a certain level of authority to be effective.
The fear of loss of status may also emerge from the conventions
and expectations of the professional and institutional sub-cultures
that exist in specific health and social care settings.

It is important that theatre artists be alert to the possibility that
resistance to participation by health and social care professionals
may be a function of fear or previous bad experiences. Although
role-play (a theatre-based educational tool) often features in the
training of many health and social care professionals, many health-
care professionals and trainees have an aversion to activities charac-
terized as "role-play." In fact, it may be best to avoid the term "role
play" completely. Instead, call it "practice" or "trying" something.
This is merely a semantic difference, to be sure, but eliminating the
use of a term that has negative connotations in the medical sub-
culture can be helpful in reducing fear and, therefore, resistance.

Administrators in health and social care settings can also reduce
fear by elevating the status of the arts within their institutions. In
capitalist societies, providing or taking away funding may be one
of the easiest ways to raise or lower status. It communicates the
value or "worth" of anything, not least theatre. Visibility is also
an important way to elevate status. Find ways to publicize theatre
for health activities taking place at your institution and elsewhere.
News items abound on the subject – from local hospital newsletters
to the pages of national and international press and social media or
television. Share these stories with key colleagues and post them on
the social media feeds associated with your institution. (The Center
for Arts in Medicine has an excellent newsletter.)

Risk

Another fear is the concern that participation in a theatre activity could create unnecessary risk to an individual participant or an entire organization. In health and social care settings, there is often fear associated with trying new things. Many of the populations served are vulnerable, and professional caregivers want to avoid unnecessary risk. Concerns about patient safety (physical and psychological) and patient privacy are legitimate and should be taken seriously. In litigious societies, risk aversion among administrators may create significant barriers to engagement with theatre in health and social care settings. Such anxieties are entirely understandable and never to be dismissed as simply alarmist. However, depending upon the context, there are typically ways to limit or eliminate risk. Negotiating around risk can also bring new learning for theatre for health professionals and organizations they look to serve.

It is true that some artists and arts educators have entered health and social care settings with good intentions but had a poor understanding of the vulnerabilities of the population they wished to serve, which may have caused harm. Increasingly, the bar is set high for any engagement with populations in statutory sites such as hospitals and care homes. It is important that individuals involved in such activities have the experience, training, and risk management profile to apply or coordinate the arts in such settings. In recent years this has been advanced in the broad domain of arts in health, and several organizations are guiding efforts to codify scope of practice and ethical standards for artists working in health and social care settings. In the United States, for example, the National Organization for Arts in Health has published its "Code of Ethics and Standards for Arts in Health Professionals" (thenoah.net/noah-publications). This document clearly outlines the activities that fall within the scope of practice for an artist or arts educator working in these settings. Also, there are various academic programs that offer training to artists and arts administrators who wish to work in health and social care settings.

Even without advanced degrees and graduate certificates in arts in health, there are ways to address concerns about liability

and patient safety. Volunteer training programs, paraprofessional programs, and even the physical location of the arts engagement can all help protect participant health, safety, and privacy. In addition, individual institutions can and should establish clear guidelines for the arts in health professionals they employ. This includes providing artists with information about what to do and who to contact in the unlikely event of an adverse reaction to an arts engagement activity. Artists-in-residence at University of Florida Health integrate with care teams and regularly consult with nurses, social workers, and creative arts therapists. In addition, they are required to document encounters with each patient they engage in their electronic medical record.

The bottom line is that every artist employed in health and social care settings needs to understand the fundamental difference between arts engagement and creative arts therapy. Arts engagement offers enjoyment, distraction, positive social interaction, skills development, and, hopefully, an improved sense of well-being. The creative arts therapies offer specific clinical and therapeutic interventions for a variety of chronic and acute conditions. The people who practice the creative arts therapies are allied health professionals who offer clinical care. Arts in health professionals often collaborate with creative arts therapists in clinical settings, but they are not there to offer treatment.

Culture Clashes

Most individuals entering specialized training spend years steeped in a particular, esoteric culture. This is as true of the health sciences disciplines as it is of the theatre. Educators in both camps devise programs to help trainees develop a deep understanding of a relatively narrow scope of practice, each with its own norms and language. This specialization means that collaboration is both essential and potentially quite difficult. Within each respective domain – theatre and health care – there are some shared norms and understandings: the meanings of different professional titles, hierarchies and chains of command, professional expectations, and the cultural norms and general protocols for executing collaborative work.

However, when arts professionals enter health or social care environments for the first time, there are many challenges that relate to culture and communication. These differences can lead to strained relationships and collaborations. If this happens, mutual respect and trust can erode or fail to develop, and seriously hamper intended outcomes. Collaborators on projects that suffer from professional culture clashes often feel betrayed and disappointed and may resist or advocate against future opportunities to bring theatre into health and social care settings.

Doing theatre in health or social care settings requires mutual respect and trust, the shared understanding of project goals (which are best developed in collaboration), and a basic understanding of each other's values, habits of language or communication, expectations, and cultural norms. All this takes time.

Most people who work in theatre are curious and genuinely enjoy learning through their collaboration with others. To make theatre we must take an imaginative leap to create characters and worlds that are quite different from our own. In order to navigate these differences, theatre artists regularly turn to area experts for guidance – that is, they do research. In clinical settings, theatre-for-health professionals learning about the impact of a condition, treatment, or process are advised to ask genuine, open-ended questions (as opposed to questions that imply judgment of clinicians) that demonstrate interest and respect for collaborators, which, in turn, helps to build trust among team members. This approach also aids in reaching a mutual understanding of what a team is doing, why they are doing it, and how they will accomplish it.

The importance of a mutual understanding of goals cannot be overstated when entering into an interdisciplinary collaboration. If everyone understands the goal, arbitrating disputes between collaborators is less fraught or ego-driven. In theatre, the mutually agreed upon goal is typically the effective telling of a particular story. The following question is key: "What story are we trying to tell our audience and why?" When there is a disagreement, the team asks, "Will this creative choice help us tell our story? How?" Clearly articulated goals, established collaboratively, help any team (interdisciplinary or not) make difficult decisions without loss of face to members whose suggestions are not followed.

Assumptions

Professionals engaged with health, social care, and theatre for health generally want to be helpful to the people we serve. We want to contribute to improving the quality of people's lives. However, sometimes we assume that our educational attainment and professional expertise qualify us to make judgments about what a community needs in order to improve its health and well-being. Our eagerness to help and the urgency of the need in certain communities are seductive forces. When coupled with unconscious biases focused, in particular, on participant deficits, we may unwittingly alienate the very people we most want to help.

Interestingly, theatre for health activities are typically strengths-based because they invite participants to restructure their identity around creativity rather than pathology. Although a workshop might be designed to accommodate the needs of people living with certain challenges, the creative activities in which they engage eschew deficit, foregrounding ability and strength instead (Sutherland, 2017). In other words, do not make the mistake of assuming that participants have little to offer or teach the professionals with whom they are working. Instead, use the frame of theatre to recognize and learn from participants' strengths, knowledge, and ways of being in the world. It is a privilege to do so.

CONCLUSION

Early in the pandemic that began in 2020, theatre artists began to experiment with creating and sharing performances online. Although most physical performance venues closed for extended periods, theatre artists and educators persisted in their work. Motivated by the need for human connection and creative self-expression, they found new ways to achieve these goals. In fact, the wider public created their own kinds of theatre and performance offline and online, among family members and friends where possible within lockdown or other restrictions. At that time, some of the challenges theatre for health professionals faced seemed as insurmountable as staging an entertaining live performance using an online streaming platform like Zoom. However, they carried on!

As always, creativity, which is at the heart of theatre for health, found its way, and, along with the wider public, we gained new insights into the vital role of the arts to counter social isolation and support physical and mental health (see Crawford & Crawford, 2021).

6

RESOURCES

USEFUL LINKS

The Alan Alda Center for Communicating Science

aldacenter.org

The Alan Alda Center for Communicating Science offers theatre-based workshops to scientists and researchers to help them better communicate complex ideas to a general audience.

American Alliance for Theatre & Education

aate.com

The American Alliance for Theatre and Education (AATE) works to ensure that every young person experiences quality theatre arts in their lives provided by proficient, talented artists and educators. AATE serves more than one million students in 48 US states and 19 countries worldwide.

Americans for the Arts

americansforthearts.org

An arts advocacy organization in the United States, Americans for the Arts partners with other arts organizations to produce and

amplify research demonstrating the value of the arts to individuals and communities.

ASSITEJ – International Association of Theatre for Children and Young People

assitej-international.org

ASSITEJ is an association of theatres, organizations, and individuals who make theatre for children and young people. It provides opportunities for members to exchange information about theatre for children and young audiences.

Educational Theatre Association

schooltheatre.org

The mission of the Educational Theatre Association (EdTA) is to shape lives through theatre education. EdTA honors student achievement in theatre, supports teachers by providing professional resources, and influences public opinion that theatre education is essential for building life skills. The International Thespian Society is part of EdTA.

HowlRound Theatre Commons

howlround.com

The HowlRound Theatre Commons is a free, open platform for theatre-makers. Their playwriting channel on YouTube has an archive of classes and interviews with playwrights and playwriting groups.

National Theatre

nationaltheatre.org.uk

Not only does the National Theatre produce and tour world-class theatre, but it also offers educational programs throughout the UK. Check out their YouTube channel for a video series in which the hosts

interview playwrights. In addition, NT's Public Arts program creates participatory theatre in partnership with local theatres and community organizations. NT also offers digital programming including National Theatre Live and the National Theatre Collection.

New Play Exchange®

newplayexchange.org

The New Play Exchange®, a National New Play Network project, is the world's largest digital library of scripts by living writers. Individuals can access a large database of scripts for a small annual fee.

Outside Edge Theatre Company

edgetc.org

Outside Edge Theatre Company is the UK's only theatre company and participatory arts charity focused on improving the lives of people affected by any form of addiction, including their families, carers, and champions.

Pedagogy & Theatre of the Oppressed, Inc.

ptoweb.org

Pedagogy & Theatre of the Oppressed, Inc. (PTO) supports people whose work challenges oppressive systems by promoting critical thinking and social justice through liberatory theatre and popular education.

The Public Theater

publictheater.org

The Public Theatre presents free plays in New York City's Central Park as well as plays both on and off-Broadway. In addition, the Public partners with organizations throughout New York City to build community through theatre, both as audience members and as participants.

RSC Open Stages

rsc.org.uk/open-stages

The Royal Shakespeare Company (RSC) collaborates with 100 amateur theatre companies from all over the UK through their Open Stages program. They offer workshops, training, and mentoring with professionals from the RSC and beyond.

Theatre Development Fund

tdf.org

Theatre Development Fund (TDF) is dedicated to bringing the power of the performing arts to everyone. It offers various programs and resources to assist theatre companies in providing access to their performances, including training on autism-friendly performances.

The Theatre Times

thetheatretimes.com

TheTheatreTimes.com is a global theatre portal that publishes articles on theatre from all over the world.

TimeSlips™

timeslips.org

Founded by MacArthur Fellow Anne Davis Basting, TimeSlips™ works to change the way people understand and experience aging. Their Creativity Center is free to all users and provides ideas for engaging elders in meaningful projects.

REFERENCES

SUGGESTED FURTHER READING

McCormick, S. 2019. *Applied Theatre: Creative Ageing*, London, Methuen Drama.

Prendergast, M. and Saxton, J. Eds. 2019. *Applied Theatre: International Case Studies and Challenges for Practice*, Bristol, Intellect.

Hatcher, J. 2000. *The Art and Craft of Playwriting*, Toronto, Story Press Books.

Swale, J. 2017. *Drama Games for Classrooms and Workshops*, London, Nick Hern Books.

Graham, S. and Hoggett, S. 2014. *The Frantic Assembly Book of Devising Theatre*, London, Routledge.

Boal, A. 1992. *Games for Actors and Non-Actors*, London, Routledge.

Weigler, W. 2001. *Strategies for Playbuilding: Helping Groups Translate Issues into Theatre*, Portsmouth, Heinemann.

Amador, S. 2018. *Teaching Social Skills through Sketch Comedy and Improv Games: A Social Theatre™ Approach for Kids and Teens including those with ASD, ADHD, and Anxiety*, London, Jessica Kingsley Publishers.

Rohd, M. 1998. *Theatre for Community, Conflict & Dialogue: The Hope Is Vital Training Manual*, Portsmouth, Heinemann.

Spolin, S. 2000. *Theater Games for the Classroom: A Teacher's Handbook*, Evanston, IL, Northwestern University Press.

Halpern, C., Close, D. and Johnson, K. 2001. *Truth in Comedy: The Manual of Improvisation*, Colorado Springs, CO, Meriwether Publishing.

REFERENCES

INTRODUCTION

Drabkin, I.E. 1951. Soranus and his system of medicine, *Bulletin of the History of Medicine*, 25, 503–518.

Jones, P. 1996. *Drama as Therapy: Theatre as Living*, London, Routledge.

McConachie, B. 2011. An evolutionary perspective on play, performance, and ritual, *TDR/The Drama Review*, 55, 33–50.

McConachie, B. 2013. *Theatre & Mind*. Red Globe Press, London and New York.

Mora, G. 1957. Dramatic presentations by mental patients in the middle nineteenth century, *Bulletin of the History of Medicine*, 3, 260–277.

Westlake, E.J. 2017. *World Theatre: The Basics*, London, Routledge.

CHAPTER 1

Alcântara, P.L., Wogel, A.Z., Rossi, M.I.L., Neves, I.R., Sabates, A.L. and Puggina, A.C. 2016. Effect of interaction with clowns on vital signs and non-verbal communication of hospitalized children, *Revista Paulista de Pediatria (English Edition)*, 34, 432–438.

Anderson, S., Fast, J., Keating, N., Eales, J., Chivers, S. and Barnet, D. 2017. Translating knowledge: promoting health through intergenerational community arts programming, *Health Promotion Practice*, 18, 15–25.

Back, A.L., Arnold, R.M., Baile, W.F., Fryer-Edwards, K.A., Alexander, S.C., Barley, G.E., Gooley, T.A. and Tulsky, J.A. 2007. Efficacy of communication skills training for giving bad news and discussing transitions to palliative care, *Archives of Internal Medicine*, 167, 453–460.

Baile, W.F., De Panfilis, L., Tanzi, S., Moroni, M., Walters, R. and Biasco, G. 2012. Using sociodrama and psychodrama to teach communication in end-of-life care, *Journal of Palliative Medicine*, 15, 1006–1010.

Bandura, A. 2001. Self-efficacy. In *The Corsini Encyclopedia of Psychology and Behavioral Science*, Eds W.E. Craighead and C.B. Nemeroff, 3rd ed., New York, NY, John Wiley & Sons.

Boersma, P., van Weert, J.C.M., Lissenberg-Witte, B.I., van Meijel, B. and Dröes, R.-M. 2019. Testing the implementation of the Veder contact method: a theatre-based communication method in dementia care, *The Gerontologist*, 59, 780–791.

Boersma, P., Weert, J.C.M. van Meijel, B. and van Dröes, R.-M. 2017. Implementation of the Veder contact method in daily nursing home care for people with dementia: a process analysis according to the RE-AIM framework, *Journal of Clinical Nursing*, 26, 436–455.

Centers for Disease Control and Prevention. 2018. Well-being concepts. *Health-Related Quality of Life*. Available at: https://www.cdc.gov/hrqol/wellbeing.htm

Chung, K.S.Y., Lee, E.S.L., Tan, J.Q., Teo, D.J.H., Lee, C.B.L., Ee, S.R., Sim, S.K.Y. and Chee, C.S. 2018. Effects of Playback Theatre on cognitive function and quality of life in older adults in Singapore: a preliminary study, *Australasian Journal on Ageing*, 37, E33–E36.

Collier, K. 2015. Transforming reflection through a forum theatre learning approach in health education. In *Playing in a House of Mirrors: Applied Theatre as Reflective Practice*, Eds. E. Vettraino and W. Linds, pp. 35–52, Rotterdam, the Netherlands, Brill.

Corbett, B.A. 2014. *The SENSE Theatre Manual: Using Peers, Play, and Performance to Improve Social Competence in Children, Adolescents, and Adults with Autism Spectrum Disorder*, Nashville, TN, VU e-Innovations.

Corbett, B.A., Blain, S.D., Ioannou, S. and Balser, M. 2017. Changes in anxiety following a randomized control trial of a theatre-based intervention for youth with autism spectrum disorder. *Autism*, 21, 333–343.

Corbett, B.A., Ioannou, S., Key, A.P., Coke, C., Muscatello, R., Vandekar, S. and Muse, I. 2019. Treatment effects in social cognition and behavior following a theater-based intervention for youth with autism, *Developmental Neuropsychology*, 44, 481–494.

Cueva, M. 2010. Readers' theatre as cancer education: an organic inquiry in Alaska awakening possibilities in a living spiral of understanding, *Journal of Cancer Education*, 25, 3–8.

Cueva, M., Dignan, M. and Kuhnley, R. 2012. Readers' theatre: a communication tool for colorectal cancer screening, *Journal of Cancer Education*, 27, 281–286.

Cueva, M., Kuhnley, R., Lanier, A., Dignan, M., 2005. Using theater to promote cancer education in Alaska, *Journal of Cancer Education*, 20, 45–48.

Fancourt, D. and Finn, S. 2019. *What is the Evidence on the Role of the Arts in Improving Health and Well-being? A Scoping Review (Synthesis No. 67), Health Evidence Network*, Copenhagen, World Health Organization.

Felsman, P., Seifert, C.M. and Himle, J.A. 2019. The use of improvisational theater training to reduce social anxiety in adolescents, *Arts in Psychotherapy*, 63, 111–117.

Friedman, D.B., Adams, S.A., Brandt, H.M., Heiney, S.P., Hébert, J.R., Ureda, J.R., Seel, J.S., Schrock, C.S., Mathias, W., Clark-Armstead, V., Dees, R.V. and Oliver, R.P. 2019. Rise up, get tested, and live: an arts-based colorectal cancer educational program in a faith-based setting, *Journal of Cancer Education*, 34, 550–555.

Hardwick, A., 2014. The contribution of applied drama to the recovery of adult substance abusers: a qualitative exploration. In *Addiction and Performance*, Eds J. Reynolds and Z. Zontou, pp. 192–213, Newcastle upon Tyne, Cambridge Scholars Publishing.

Heard, M.E., Mutch, A., Fitzgerald, L. and Pensalfini, R. 2013. Shakespeare in prison: affecting health and wellbeing, *International Journal of Prisoner Health*, 9, 111–123.

Hui, C.L.M., Leung, W.W.T., Wong, A.K.H., Loong, K.Y., Kok, J., Hwang, A., Lee, E.H.M., Chan, S.K.W., Chang, W.C. and Chen, E.Y.H. 2019. Destigmatizing psychosis: investigating the effectiveness of a school-based programme in Hong Kong secondary school students, *Early Intervention in Psychiatry*, 13, 882–887.

Huppert, F.A. and So, T.T.C. 2013. Flourishing across Europe: application of a new conceptual framework for defining well-being, *Social Indicators Research*, 110, 837–861.

Kafewo, S.A. 2008. Using drama for school-based adolescent sexuality education in Zaria, Nigeria, *Reproductive Health Matters*, 16, 202–210.

Keisari, S. and Palgi, Y. 2017. Life-crossroads on stage: integrating life review and drama therapy for older adults, *Aging and Mental Health*, *21*, 1079–1089.

Keisari, S., Palgi, Y., Yaniv, D. and Gesser-Edelsburg, A. 2020. Participation in life-review playback theater enhances mental health of community-dwelling older adults: a randomized controlled trial, *Psychology of Aesthetics, Creativity, and the Arts*, 1–16.

Kontos, P.C., Miller, K.-L., Gilbert, J.E., Mitchell, G.J., Colantonio, A., Keightley, M.L. and Cott, C. 2012. Improving client-centered brain injury rehabilitation through research-based theater, *Qualitative Health Research*, *22*, 1612–1632.

Kontos, P.C., Mitchell, G.J., Mistry, B. and Ballon, B. 2010. Using drama to improve person-centred dementia care, *International Journal of Older People Nursing*, *5*, 159–168.

Logie, C.H., Dias, L.V., Jenkinson, J., Newman, P.A., MacKenzie, R.K., Mothopeng, T., Madau, V., Ranotsi, A., Nhlengethwa, W. and Baral, S.D. 2019. Exploring the potential of participatory theatre to reduce stigma and promote health equity for lesbian, gay, bisexual, and transgender (LGBT) people in Swaziland and Lesotho, *Health Education and Behavior*, *46*, 146–156.

Loth, J., Penton, J. and Andersen, P. 2016. Acting 4 health: a complementary curricular approach for drama and healthcare studies, *Applied Theatre Research*, *4*, 255–268.

Mitchell, K.S. and Freitag, J.L. 2011. Forum Theatre for Bystanders: a new model for gender violence prevention, *Violence Against Women*, *17*, 990–1013.

Moran, G.S. and Alon, U. 2011. Playback theatre and recovery in mental health: preliminary evidence, *Arts Psychotherapy*, *38*, 318–324.

Pleasant, A. 2017. Assisting vulnerable communities: Canyon Ranch Institute's and Health Literacy Media's health literacy and community-based interventions, *Studies in Health Technology and Informatics*, *240*, 127–143.

Pleasant, A., de Quadros, A., Pereira-León, M. and Cabe, J. 2015. A qualitative first look at the Arts for Behavior Change Program: Theater for Health, *Arts and Health*, *7*, 54–64.

Rogers, C.R. 1980. *A Way of Being*, Boston, MA, Houghton Mifflin.

Rodriguez, J., Rich, M.D., Hastings, R. and Page, J. 2006. Assessing the impact of Augusto Boal's "proactive performance": an embodied approach for cultivating prosocial responses to sexual assault, *Text & Performance Quarterly*, 26, 229–252.

Rustveld, L.O., Valverde, I., Chenier, R.S., McLaughlin, R.J., Waters, V.S., Sullivan, J. and Jibaja-Weiss, M.L. 2013. A novel colorectal and cervical cancer education program: findings from the community network for cancer prevention forum theater program, *Journal of Cancer Education*, 28, 684–689.

Sextou, P. and Hall, S. 2015. Hospital theatre: promoting child well-being in cardiac and cancer wards, *Applied Theatre Research*, 3, 67–84.

Tarasoff, L.A., Epstein, R., Green, D.C., Anderson, S. and Ross, L.E. 2014. Using interactive theatre to help fertility providers better understand sexual and gender minority patients. *Medical Humanities*, 40, 135–141.

Tian, H., Niu, W., Liu, P., Wang, N., Yu, H. and Zhao, Z. 2014. Effects of psycho-scene-drama on empathic ability of patients with chronic schizophrenia, *Family Medicine and Community Health*, 2, 53–58.

Umberson, D. and Montez, J.K. 2010. Social relationships and health: a flashpoint for health policy, *Journal of Health and Social Behavior*, 51, S54–S66.

Wells, T. 2013. Insights into approaching sexual health education through applied theatre methodology, *Applied Theatre Research*, 1, 203–215.

Zeisel, J., Skrajner, M.J., Zeisel, E.B., Wilson, M.N. and Gage, C. 2018. Scripted-IMPROV: interactive improvisational drama with persons with dementia – effects on engagement, affect, depression, and quality of life, *American Journal of Alzheimer's Disease and Other Dementias*, 33, 232–241.

CHAPTER 2

Corbett, B.A. 2014. *The SENSE Theatre Manual: Using Peers, Play, and Performance to Improve Social Competence in Children, Adolescents, and Adults with Autism Spectrum Disorder*, Nashville, TN, VU e-Innovations.

Detroit Creativity Project. n.d. Available at: https://detroitcreativityproject.org/

Felsman, P., Seifert, C.M. and Himle, J.A. 2019. The use of improvisational theater training to reduce social anxiety in adolescents, *Arts in Psychotherapy*, *63*, 111–117.

Fox, P. 2014. Afterword: Outside Edge: addiction recovery theatre – a theatre of survival and revolution in hard times. In *Addiction and Performance*, Eds J. Reynolds and Z. Zontou, pp. 358–384, Newcastle upon Tyne, Cambridge Scholars Publishing.

Gray, J., Kontos, P., Dupuis, S., Mitchell, G. and Jonas-Simpson, C. 2017. Dementia (re)performed. In *Care Home Stories, Aging, Disability, and Long-Term Residential Care*, Eds S. Chivers and U. Kriebernegg, pp. 111–126, Bielefeld, Transcript Verlag.

Jackson, M.E. 2017. Improv at school: lessons from Detroit's young improvisers. *Applied Improvisation World Conference*. Available at: https://youtu.be/D-qMgRrGTB4

Jones, P., 1996. *Drama as Therapy: Theatre as Living*, London, Routledge.

Reynolds, J. 2017. Outside edge's theatre for recovery: reshaping influence and the addict identity, *Performance Research*, *22*, 73–82.

Schweitzer, P. 2007. *Reminiscence Theatre: Making Theatre from Memories*, London, Jessica Kingsley Publishers.

Sextou, P. 2016. *Theatre for Children in Hospital: The Gift of Compassion*, Bristol, Intellect.

Sextou, P. and Hall, S. 2015. Hospital theatre: promoting child well-being in cardiac and cancer wards, *Applied Theatre Research*, *3*, 67–84.

Sextou, P. and Monk, C. 2013. Bedside theatre performance and its effects on hospitalised children's well-being, *Arts and Health*, *5*, 81–88.

CHAPTER 3

Ball, D. 1983. *Backwards and Forwards: A Technical Manual for Reading Plays*, Carbondale, SIUP.

Beckett, S. 1971. *Breath and Other Shorts*, London, Faber and Faber.

Boal, A. 1992. *Games for Actors and Non-Actors*, London, Routledge.

Brook, P. 1977. *The Empty Space*, London, Hart-Davis, MacGibbon, Ltd.

Gervais, R. and Merchant, S. 2013. *Life's Too Short*, New York, NY, HBO Studios.

Halpern, C., Close, D. and Johnson, K. "Howard," 2001. *Truth in Comedy: The Manual of Improvisation*, Englewood, CO, Meriwether Publishing.

New Play Exchange. Available at: https://newplayexchange.org/.

Spolin, V., 1999. *Improvisation for the Theater: A Handbook of Teaching and Directing Techniques*, 3rd ed., Evanston, IL, Northwestern University Press.

CHAPTER 4

Bucciarelli, A. 2016. The art therapies: approaches, goals, and integration in arts and health. In *Oxford Textbook of Creative Arts, Health, and Wellbeing: International Perspectives on Practice, Policy, and Research, Oxford Textbooks in Public Health*, Eds S. Clift and P.M. Camic, pp. 271–277, Oxford, Oxford University Press.

Cueva, M. 2010. Readers' theatre as cancer education: an organic inquiry in Alaska awakening possibilities in a living spiral of understanding. *Journal of Cancer Education*, 25, 3–8.

Dream Doctors Project. Available at: https://dreamdoctors.org.il/

Ford, K., Courtney-Pratt, H., Tesch, L. and Johnson, C. 2014. More than just clowns: clown doctor rounds and their impact for children, families and staff. *Journal of Child Health Care*, 18, 286–296.

Gwinn, P. 2003. *Group Improvisation: The Manual of Ensemble Improv Games*, Colorado Springs, CO, Meriwether Publishing.

Langlois, S., Teicher, J., Derochie, A., Jethava, V., Molley, S. and Nauth, S. 2017. Understanding partnerships with patients/clients in a team context through verbatim theater, *MedEdPORTAL: The Journal of Teaching and Learning Resources*, 13, 10625.

Saldaña, J. 2005. *Ethnodrama: An Anthology of Reality Theatre*, Lanham, MD, Rowman Altamira.

Swale, J. 2017. *Drama Games for Devising*, London, Nick Hern Books.

TimeSlips. Available at: https://timeslips.org/

CHAPTER 5

Center for Arts in Medicine. Available at: https://arts.ufl.edu/academics/center-for-arts-in-medicine/

Crawford, P. and Crawford, J. 2021. *Cabin Fever: Surviving Lockdown in the Coronavirus Pandemic*, Bingley, Emerald.

National Organization for Arts in Health. Available at: https://thenoah.net/

Fancourt, D. 2017. *Arts in Health: designing and Researching Interventions*, Oxford, Oxford University Press.

Gwinn, P. 2003. *Group Improvisation: The Manual of Ensemble Improv Games*, Colorado Springs, CO, Meriwether Publishing.

Sutherland, A. 2017. Method and madness: de/colonizing scholarship and theatre research with participants labelled mad, *Research in Drama Education*, 22, 427–435.

INDEX

Accessible performances, 43–44
Acting, 22
 classes, 38
 skills, 22
 teachers, 23, 72
Actors, 3–4, 6, 18–24, 26–27, 36, 38,
 40, 42–43, 53, 61, 67
Adults, theatre for, 23–27
Alan Alda Center for
 Communicating
 Science, 81
Amateur drama, 39–40
American Alliance for Theatre and
 Education (AATE), 81
Americans for the Arts, 81–82
Apollo (Greek god), 2
Applied theatre, 6
Aristotle (*see Poetics, The*)
ASSITEJ, 82
Assumptions, 78
Athenian theatre, 5
Audio description, 43
Autism-friendly performances, 44
Autistic youth, theatre for, 21–23

Back-stage tours, 41–42
Backwards and Forwards: A
 Technical Manual for
 Reading Plays (Ball), 33
Banking model of education, 14
Bedside theatre, 17–20
Being in the moment, 47–49
Beliefs, 67–68, 73–74
Birmingham Repertory Theatre, 32
Boal, Augusto (*see* Forum Theatre)
Bookstores, 31

Border Crossing, 26–27
"Boy and a Turtle", A (Sextou),
 18–19

Catharsis, 2, 5
Characters, 36
Children, theatre for, 17–23
Clinical stress, 18
Clown doctors (*see* Medical
 clowns)
Clowning, 61–63
Coached Rehearsal Techniques
 for Interpersonal
 Communication Skills
 (CRiTICS), 23–25
Community theatre, 39–40
Costumes, 36
Creative storytelling, 55–57
Culture clashes, 76–77

Dementia patients, 13
Detroit schools, 20
Devising new plays, 61
Diabetes educators, 10
Dialogue, 36
Dionysus (Greek god), 2
Drama anthologies, 32
Dramatherapy, 3
Dramatic projection, 3
Drop-in Drama, 26

Educational primary intention, 14
Educational Theatre Association
 (EdTA), 82
Empathy, 5
Empty Space, The (Brook), 33